[STUFF]

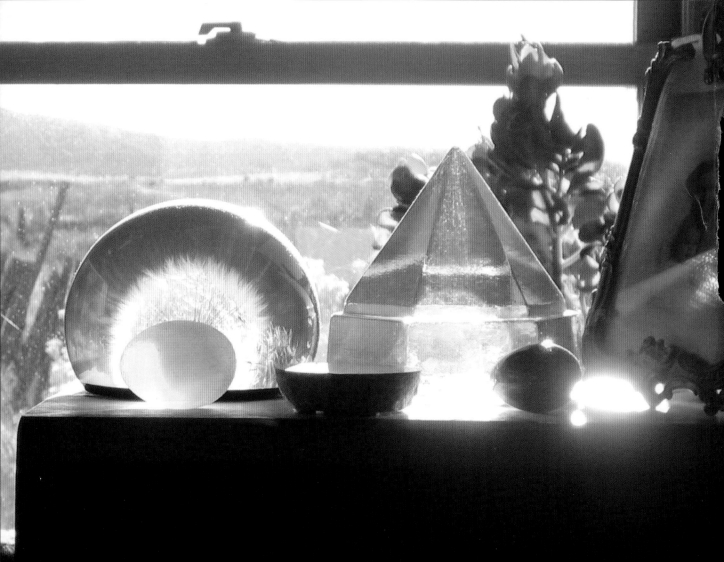

# STUFF

*Instead of a Memoir*

Lucy R. Lippard

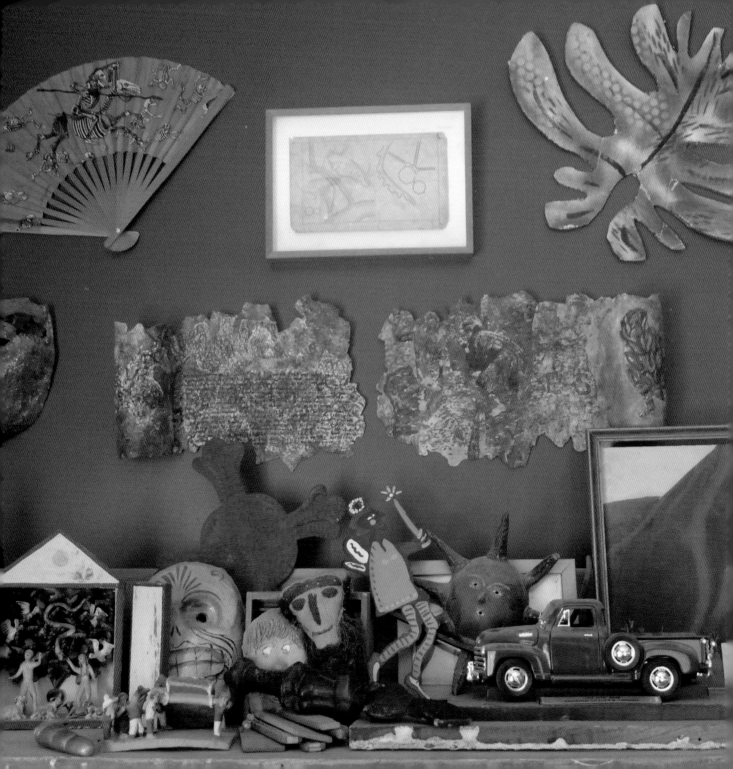

To a lifetime's worth of family, friends,
and lovers, plus critters.

"...the past is not for living in. It is a well of conclusions
from which we draw in order to act."
— John Berger, *Ways of Seeing*

The STUFF *of Memory*

WHY IS THIS NOT A MEMOIR? Because I have never had any interest in writing one, spilling the dramas and all the ups and downs. I've discouraged a couple of would-be biographers until after I'm gone, so I'm not around to nitpick, micromanage, and tear my hair over misinterpretations. (My mother always said that her worst nightmare was the existence of an afterlife; I agree, so let the chips fall where they may.) Decades ago, I thought about writing object-induced memories — using the stuff I live with to tell an oblique life story. I sounded out friends about the idea, receiving nothing but encouragement. And I never got around to it until now, in my mid-eighties, an age at which one tends to look back. I've always been more interested in looking ahead to new projects, and this is one.

It's the easy way out. In my declining years, I spend more time looking around and outwards in my little house with lots of windows. The stuff that surrounds me crowds in with memories. I read somewhere that a biography is the sculpting of space and time. "We write a room," "read a room," or "read a house," says Gaston Bachelard in *The Poetics of Space,* "then the reader who is 'reading the room' leaves off reading and starts to think of some place in his [sic] own past."

Breezing through a life in art and place, with an emphasis, as in my writing, on context and content, I'd like to avoid the fetishism attached to objects and focus on the multiple ways that they have accompanied my life. I guess I'm guilty of dragging these things into my own orbit, as though they have little meaning outside of what they mean to me. That's wrong, of course. They have lives of their own, and when I die, they will go on to have new lives, in different rooms.... or dumps. They will be freed from the tentacles of my ownership, my memories, although some might continue in my family, via my two grandsons whose lives are already very unlike mine.

As an active, if whiny, octogenarian, I spend a lot of time sitting in my father's old Lazy Boy and working from a makeshift desk on top of my dog's crate bed, looking around the one room house I built in 1993. Each object is a memory, even the leggy, out-of-control geraniums (which my gardener mother found déclassé and friends keep telling me to cut back). Time and cultural histories are embedded in these objects,

ii

which reflect an array of friendships and cultural leanings over my lifetime. Believe it or not, the objects noted here are a selection; some of the favorites had to be left out and many are sequestered in the museum. Some are considered works of art, others have no value as such. Several of them were handed down from two or three generations of my mother's family, while others recall my own life decades ago, and others are "exotic"— i.e. objects to which I'm attached but about which I am mostly ignorant.

Books like this, recording trips around rooms and homes and their contents, are not uncommon. Here are a few that I noticed recently: Xavier de Maistre's *A Journey Around My Room* was first published in French in 1794 (Richmond, Surrey, UK: Alma Classics, 2017); in 1971 Nancy Holt made a piece called *Studio Tour: Daytime,* a typed journey around her back room in New York City. Decades later, there is Sonia Lenzi's *Take Me to Live with You* (Heidelberg: Kehrer Verlag, 2021), Margaret Randall's *My Life in 100 Objects* (New York: New Village Press, 2021), and Lydia Ourahmane's 2021 exhibition in Basel comprised of everything in her apartment (a probably unknowing reprise of a 1964 Lucas Samaras show of his bedroom in the Green Gallery). On a more distant ring, I read somewhere that an interior decorator can be seen as a kind of three-dimensional biographer, a space and memory sculptor. In my house, that's me; the interior design is decidedly amateur.

◆

I've had a very lucky life, beginning with loving and supportive parents and charging along with a lot of good friends and lovers. Telling a personal story at this age is challenging. Life changes as you live it, and remembering it accurately is far more impossible than we might think. I've heard that the more you remember, the more inaccurate the memories are likely to be. What about all those people and parts of my life, even currently, that are no longer represented by objects? They are not forgotten, but they are not present here either, in part because I gave most of the art that had been given to me by friends to the New Mexico Museum of Art, where it was shown in the late 1990s: *From the Sniper's Nest: Art That Has Lived with Lucy R. Lippard*. I made the museum accept a lot of art-related tchotchkes as well, which I now regret. If all these art works were in my little house, this would be an art book instead of a light read, and my home would be too crowded to occupy.

As I write, concentrating on minutiae, the familiar world around us may be coming to an end, given climate chaos, extinctions, pollutions, pandemics, elections, and fires. An archive of small lives will mean very little if these potential disasters win out, as they seem to be doing in 2022. I write about this and art and place, and local history, trying to grasp the situation... as though it would make a difference.

iv

When I started this project, I was intrigued by the drastic differences — emotional, economic, nontraditional — in the lives of my two pairs of grandparents, my parents, myself, and those of my son and grandsons over the five generations I have known personally. Family histories, the handwritten autobiographies of several (male) ancestors and boxes of old photos and letters, too many unlabeled, grabbed me long ago and now they are interfering with my plans to concentrate on objects. Books often lead writers down paths they had not intended to explore. So, maybe, after all, this is becoming a kind of a breezy autobiography, a tell-very-little memoir.

◆

I look around my one-room house (plus separate workroom/guestroom) in a tiny New Mexico village where I've lived since 1993. I look up the ladder at my sleeping loft, piled with clothes and books. (I'm ridiculously proud of living like a teenage boy.) I look out the windows at a cottonwooded bosque on one side, shading the shallow stream that is the Rio Galisteo, and miles of yellow brown, sometimes green rangeland, blue mountains beyond, a couple of neighbors, and a usually sleepy rural highway on other sides. I'm a packrat, and my living space has always been full of personally meaningful stuff and good art — some of it by people who have become

[10]

famous, some by people who were just as good but never hustled or made it, some by son and grandsons … with overlaps.

And books, thousands of them even after I cleared out my New York loft when I moved to New Mexico; no visitor got out the door without taking something, even a rolled-up Anaconda skin. But in thirty years, I have managed to fill up my living and work rooms again. When I was building the house, I cut out a cartoon for my notebook on the process that says it all: Two ladies are having tea in a cluttered environment. One says, as I recall: "Our tastes really run to the minimal, but we never had enough space."

My room is a site of memory, fondness, joy, ruminations, occasional regrets. But if I had written this forty or fifty years ago the "stuff" would have been very different... life, wall space, friendships, possessions, and obsessions evolve. I've always loved things with a history, used things, second-hand furniture, dishes, clothes, leftovers, every-thing — a habit probably caught from my Depression-era parents: my mother haunted thrift shops (out of town, so her wealthier friends wouldn't recognize their donations) and my equally thrifty father always asked about recent purchases, "Will that last twenty years?"

1

2

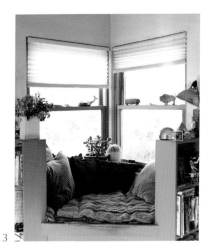

3

The beat-up telephone-wire spool,[1] now a table, was my first piece of furniture in New Mexico — a gift washed up from the Rio Galisteo. On it perch a few survivors from my once extensive ball collection (I was encouraged to call them spheres). The beautiful white-with-brown geometric rug from Botswana was $15 at a Galisteo yard sale. My handsome futon couch came from another one. I love yard sales but have given them up as I can't cram another sliver into the house. Other furniture includes my father's re-upholstered Lazy Boy, two wicker porch chairs and an old-fashioned ottoman also from the New Haven homes of my parents and great great aunts, and the long coffee table (originally orange, then green, then white, now black) made for me by Sol LeWitt;[2] he complained no one ever saw it because it was always covered with books.

In both New Mexico and Maine, I have window seats,[3] my nests — what every writer needs, to be cozy at home and also able to see far out into the world. Perched on the windowsills are a pipestone Native American bird pipe, a brass buffalo from great grandparents, a wooden "New Guinea pig," and an inherited golden Chinese fish box. On one of the narrow bookcases that frame the seat are a glass ship's binnacle from Nancy Holt, a little glass open hand from Morgan Thomas, and a glass paperweight dome containing a dandelion-like flower gone to seed, frozen

---

1. Superscript numerals refer to numbered images throughout the text, and Illustration Notes beginning on page 131.

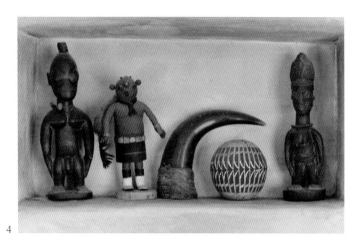

4

in the process of blowing away, from my old friend Anne Twitty, brilliant and eccentric poet, translator, and spiritual guide, who like me haunts second-hand stores.

One bookshelf by the window has two shelves of my own books (this one will be the 27th or so) plus several on Newfoundland, the Nuba of Sudan, and Navajo by my partner James C. Faris, and a pile of poetry books by college friend 'Lyn (C.B.) Follett, former poet laureate of Marin County. My own publications range all over the place too, from my first: the long captions for a book edited by James Thrall Soby and Alfred Barr on the Museum of Modern Art collection, to this one, perhaps my last.

Next to the ladder up to my sleeping loft there is a little neo-kiva fireplace, [4,5] replacing a shallow closet when I realized I would need fires. (New Mexico is sunny but we are well over a mile high, so we have normal northern

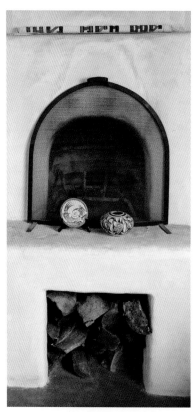

5

6

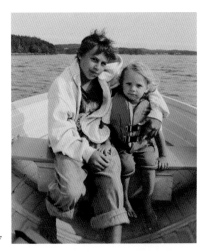

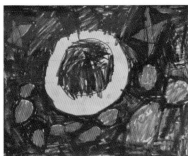

winters with snow and ice, though climate chaos is playing with all that.) On the mantel is a geometrically beaded African wand from Kathy Vargas. In a *nicho* above: a shiny black buffalo horn handed down from my western great grandparents, two wooden *ibeji* figures my father brought from Nigeria just in time for my wedding in 1961, a small black and white Acoma seed pot I bought as a gift but couldn't give up, and a Hopi mudhead kachina I bought on First Mesa from carver Edna Jackson when I was first wandering around the west on my own in the early 1990s. Although the mudhead has lost a couple of attributes, he has a value-added addition—a wisp of blessed gray down (cloud) given me by Phillip Tuwaletstiwa, a Hopi friend in Galisteo, on the occasion of my book *Down Country* (2010). He and his artist wife Judy also gave me the beautiful little Hopi pot which I managed to break a few years later. I'd warned them that it wouldn't survive my sloppy lifestyle.[6] But my patient friend Walt Stevens managed to put it back together as a surprise. It now partners with a handsome Darlene Nampeyo clay plaque from Hopi.

Of course there are pictures of friends and family: photographs of little boys who have become men, my adored son and grandsons.[7] I wish I knew the boys better, though I see them mostly in summers. ("Well, Mom, you're the one who moved a thousand miles away...") No little girls in this family, alas, but a beloved ex-daughter in law. And of course I have grandkids' child art: a magnificent *Black Hole* by Samuel Justice Ryman, age maybe ten,[8] and

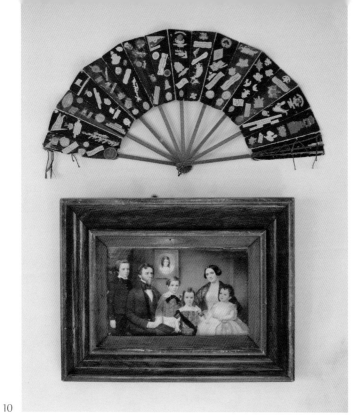

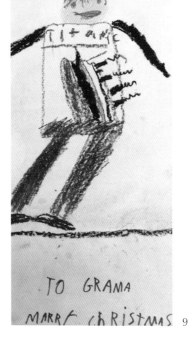

a dancing figure with a Titanic t-shirt by a younger Calvin Tracy Ryman inscribed "To Grama, Marry Christmas." [9]

◆

The *Isham Family*, 1853, by George Freeman, [10] who also painted Queen Victoria, is supposedly one of the largest known works painted on ivory. Hanging over the portrait is a probably early-20th-century touristic fan emblazoned with stickers from places visited (mostly in Maine, including the town of Bath, where I bought it at an antique store). I like the coy expansiveness of fans and there are several others around the house.

[15]

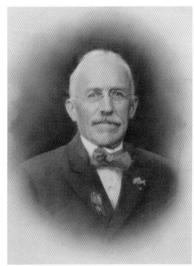

11

12

The solidly bourgeois parents in this portrait are Joseph Giles Isham (1811–1888) and Christina Beach Isham (1818–1904). The portrait on the wall is of their daughter Christina, who died very young, next comes Christina "the second" (1844–1852) who didn't last long either; Joseph Henry Isham (1842–1884), John Beach Isham (1847–1894), Frank Worthington Isham (1849–1926) and Edward Isham (1850–54). Four more children were born after this portrait — one died of scarlet fever at age four and another died at age one. Two girls survived: Christine Addison Isham (Mrs. Rufus Waples, b. 1857, who died in El Paso, Texas in 1898) and Edyth Hayward Isham (Mrs. Marcus Mason, 1860–1924).

In a pocket on the back of the family portrait's wooden frame is the agreement between the artist and Joseph Isham for $300. But it notes, after half the fee was paid, "a disagreement has arisen in regard to the faithfulness of the likenesses," and the painter was to come to the Isham home in Sing Sing (Ossining up the Hudson, best known as the prison site) to make alterations by September 1854. Lawyers were involved and the document was signed by both parties. I look back with (mostly) pride at both my enterprising and failed ancestors. These were the last wealthy ones.

Frank (FWI),[11] in corkscrew curls and a mourning sash, is my maternal great grandfather, the longest-lived and most adventurous in the family. Once on the staff of *The Nation,* he eschewed the familial tradition of Ivy League to merchant, choosing instead to be a farmer, teacher, rancher, miner, and amateur photographer in the Wild West. He

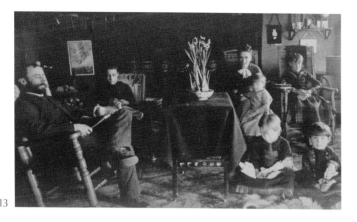
13

14

homesteaded in Dakota Territory where he constructed a grand entrance to his 1200-acre Buffalo Head Ranch from the buffalo skulls tragically scattered across the prairie. After several attempts, he finally got in a good wheat crop, at which point, on October 23rd, 1887, his house and barn burned down, crop included. The fire was blamed on a "half breed" related to Edith Eagle, who was their "hired girl," although in Frank's daughter Christina's skillfully fictionalized account of the fire she blames it on a lantern swinging in the wind. Frank's wife, Mary Rowland (he called her Mother Mary),[12] from a well-to-do New Haven family, showed her "grit" throughout, walking a half mile, at night, to recover some clothes from the burning house and helping to save the horses. Everything was reduced to ashes, including wedding presents of Tiffany silver, which melted; at least one item was eventually recast.

The family of parents and five girls[13, 14] made it to a neighbor's ranch. The community cared for them until they made

the next move. From then on, FWI's ranching was for others — first at the L.C. Ranch, owned by his sister Edyth, in Horse Creek, near Little Bear, Wyoming. When her husband went back east to sell the ranch, he stopped at Niagara Falls where he was swept into a whirlpool and drowned. The Isham family's next stop was the Garden Ranch at Templeton Gap near Colorado Springs which raised dairy cows. Tiring of this, FWI seems to have sent his wife back east with little money and took off for the gold rush at Cripple Creek, near Denver, spending years chasing mining claims around the west and in Alaska with some success and some lack thereof. One of his five daughters declared him a failure, but it looks as though he enjoyed life immensely. Known to his grandchildren as "foxy Grandpa," FWI was a character. My mother told stories about his visits. He spoke to an imaginary dog living in the piano and, when he took the kids out, he sometimes walked with one foot on the curb and one in the gutter. They were embarrassed and impressed; he seems to have inspired the generationally goofy Isham sense of humor.

◆

My other maternal great grandfather, Reverend Roselle Theodore Cross (1844–1924),[15] son of Reverend Gorham Cross and Sofia Murdoch Cross, was born and raised in Richville, New York, attended Oberlin College, and became Principal of the Preparatory Department there. He met and became engaged to Emma Asanath Bridgman,[16] but she left to teach freed slaves in Georgia, and he didn't see her again

for three years. After their marriage he decided to be a full-time pastor, studying at Union and Andover theological seminaries and serving in SiouxFalls, South Dakota, York, Nebraska, Colorado Springs, and West Denver. By the time they took a train west from Ohio (Emma had just buried her mother), they had lost two children to illness. (I inherited a whole hand-written notebook — a detailed account of the very short life of "Little Thedie.")[17] Roselle was an amateur mineralogist and a home missionary/circuit rider in the mountains of Colorado. One of his books is called, imperially, *My Mountains;* to my amazement it is listed today on Amazon with five of his other tomes.

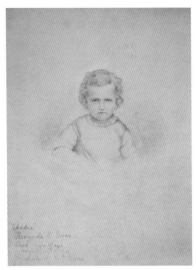

17

After his arrival in Colorado in 1876, Roselle hiked from Ouray to Telluride over the mountains, encountering an unidentified "wild beast" (a bear?) on the way. On a train trip from Albuquerque to California, he spotted "the skeleton of a horse standing up, as though he had forgotten to lie down when he died." In June 1880 he led a group of young "explorers" to the "discovery" of the Cave of the Winds in Manitou Springs, Colorado, where, coincidentally, J.B. Isham, my great great uncle from the other side of the not-yet-connected family, a surgeon for the Pikes Peak Railway, had built a sort of Swiss chalet.[18] Roselle was taking his Sunday school class to see a small cave nearby, but the owner was drunk and demanded money, so (family legend goes) he said "Come on, boys. We'll find our own cave!" And they did. The real "discoverers" of the cave were the "Pickett boys," whose father had recently died when his

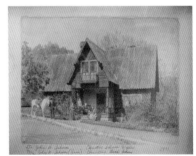

18

[19]

19

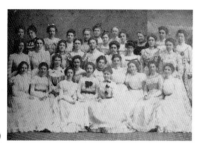

20

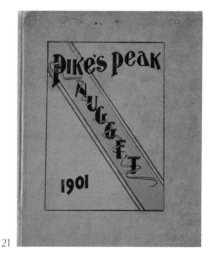

21

stage overturned in a snowstorm. They were the ones who climbed the hill and found the hidden entrance. Within a few days Cross wrote about the cave in his church newsletter, and it was immediately reprinted in the *Colorado Springs Gazette* (July 2, 1880). The *Colorado Encyclopedia* noted: "Although Cross exaggerated the heights and depths of vertical elements, as do most inexperienced cavers, his account is remarkably free of the florid Victorian hyperbole typical of most cave descriptions of that time." He and his Boys' Exploring Association traversed "the horizontal passages accessible from the original entrance, a distance of about 200 feet — a respectable distance for schoolboys using candles." Roselle broke off stalactites and sold them to benefit his church.

◆

My mother's father, Roselle's son Judson Lewis Cross, named after one of his uncles, was born November 10, 1878, in York, Nebraska, where Roselle was a pastor. Judson was the last in a long line of Congregational ministers. Family lore had it that he would rather have done something else. All of his heirs are agnostics and atheists. He met my grandmother, Florence Emily Isham,[19] at Colorado College, class of "ought one" (1901) when the entire faculty and student body numbered around sixty-five. There is a photo of them all sitting on a small hill. "Miss Isham" was the school tennis champion, captain of the women's basketball team (called "Yale"), member of the Minerva Society,[20] and artist for the 1900 yearbook, *The Nugget*.[21]

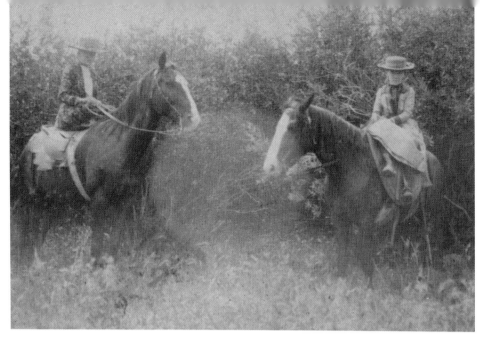

22

Judson was an early "ranger" at Yellowstone National Park in the 1890s. He told of eating rattlesnake and other adventures. (Actually, given his laconic datebook, the job seemed to include random tasks, like dishwashing.)

◆

My Grannie, Florence Isham Cross, was the second of the five sisters; the oldest, Christina, apparently died in her thirties. Though I like the name Christina (pronounced with a hard i), if I'd had a girl, I would have avoided it, as three Christinas in two generations died as children or before middle age. Grannie told wonderful stories about riding Indian ponies (hers was called Ribbon, and Christina's was Stockings) across the plains.[22] This made a big impression on me as a child, as I was a horse-crazy girl, though I never owned one. When I started to spend time in the west, part-time teaching at the University of Colorado Boulder in my late forties and early fifties, and the University of Wyoming for two months in my late seventies, I felt as though I was coming home. Sometimes I thought I could sense the history coming up from under the ground.

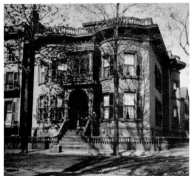

23

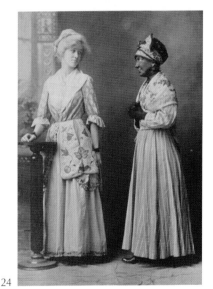

24

◆

My middle name is Rowland after my maternal great grand-mother Mary's mercantile family. Her brother, Edward Rowland, named after the patriarch, came to settle near his sister in Dakota Territory in the 1880s, apparently having been kicked out of Yale for a chorus girl problem. In early January 1891 he was seen acting peculiar, jumped into a hole, and shot himself. The *Ransom County Gazette* reported that "the deceased was about 34 years of age ... and was very much liked by everybody."

I knew Florrie, one of Mother Mary's sisters, who, with Fannie and Josie, other maiden and widowed great great aunts, lived at 42 Academy Street in New Haven, in a handsome old brownstone on historic Wooster Square that survives today. [23] A postcard photo shows her in a 1914 historical performance, playing a maid in blackface — very much opposed to the other side of the family's history of abolition and anti-racism.[24] Aunt Florrie fell ill at a ripe old age while visiting us in Maine when I was a child. I remember her in bed, small and wizened, a ghostly apparition, and my first perception of death. From that side of the family, which included Pecks and Fitches, among them the legendary Yankee Doodle, I have various hand-me downs: an old-fashioned terrarium, a silhouette portrait,[25] a graceful ottoman, and a yellow vel-

25

[22]

vet boudoir chair that was broken on its way to a new home in New Mexico. There is also a jointed Indian male "doll," a beaded purse from a Plains tribe, and a decorated metal stamp box [26] from my grandmother labeled "Given me by Grace Hibbard first secretary of state for Wyoming … 1889."

◆

After graduation from Colorado College, Judson Cross and Florence Isham left the West, never to return. My grandmother admitted in old age that she had not actually graduated because she "took too many art classes." [27] She briefly attended the Chicago Art Institute to study scientific illustration, specializing in trilobites, before joining Judson at the Yale Divinity School. They were married in New Haven in 1904. He was a chaplain in Europe at the end of WWI, pastor at various churches in New York State, in Trumbull, Connecticut, where my mother was born, then in Fitchburg, Massachusetts, where she and her younger sister and brother were raised, and lastly in nearby Winchester.

Grandpa's last post (1935–1947) was as President of the historically Black Tougaloo College in Jackson, Mississippi, where he groomed the first Black president. [28] (I was the only white child at my fourth birthday party there.) Each summer in Maine, a Tougaloo student came with the family, not as a "maid," though she did work in the house, but she ate at the table as a member of the family. The ones I remember with great fondness were Henrietta Thigpen, Janie Singletary, and Lavertis Keyes. For years there was a

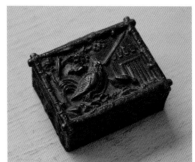

26

27

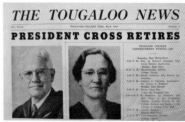

28

29

30

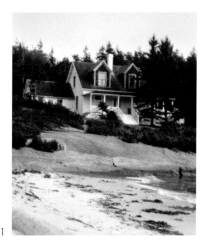

31

Tougaloo dorm named after Judson L. Cross [29] and a garden named after my grandmother. But "not anymore!" as I was wryly informed by an African American lawyer with the Center for Constitutional Rights when I served on its board in the early 1980s.

My mother Margaret Isham Cross (Lippard) [30] and her younger sister Elizabeth Murdoch Cross (Langmuir) may have been surprised by the birth, years later, of their brother Judson Bridgman Cross, who I called my "Funny Uncle Jud," for his off-beat sense of humor. In 1915, the Crosses were invited to visit a congregant, Mrs. Brown Rich Bowen, at Overlook, her elegant summer "cottage" in Georgetown, Maine, at the mouth of the Kennebec River. They took boats from Boston to Portland to Popham Beach to Bay Point to Kennebec Point, arriving at sunrise and falling in love with the place. For a few summers they rented houses there, and finally bought High Tide, [31] a former "shooting lodge," perched on rocks over a white sand beach since the 1880s. This is where our family convenes each summer, and I have never missed one.

My father was born and raised in Marlborough, Massachusetts, son of two factory workers. [32] His father Will (William Charles Lippard), was born in England in 1869. He was twelve when he was orphaned in East London. His parents, originally from Kent, left no will, so everything went to the King's Exchequer. For six or seven years Will lived on his own, sometimes as a waif under the Tower Bridge, then became a cabin boy, which eventually got

him to Marlborough, Massachusetts, to reunite with his sister and three brothers.

My paternal grandmother, Lucy Maria Balcom, was born April 18, 1869 (an Aries like me) to a farming family in Lawrencetown, in Nova Scotia's Annapolis Valley. Her ancestors (some named Morse) had lived in New England in the seventeenth and early eighteenth centuries, but as Tories, they fled to Canada in opposition to the American Revolution. Although she had been a Normal School teacher in her teens, for some reason Lucy emigrated to work in a shoe factory in Marlborough, where she met Will Lippard. (The factory was managed by his Uncle Mort, the bastard son of my great grandmother and a Lord Mortimer. Mort had attended Oxford and was then shipped off to the US.) Gramma Lucy was lovely, and loving, but quiet, and she died of cancer before I was old enough to ask the right questions. I never found out why she emigrated, never heard anything about her past. A long lost and finally found cousin, Liz Lippard Sniderman, recently gave me a little autograph book from 1889 that belonged to a young Lucy. [33]

On the other side of the family, there was another Lucy, great great aunt Lucy Anne Cross (1839–1927) who went to Oberlin and in 1879 landed in Florida, where she was instrumental in the founding of Rollins College, site of today's Lucy Cross Center for Women, Gender, and Sexuality (aka "the Lucy"). According to family lore, when women finally got the vote in 1920, she stood in line for hours to

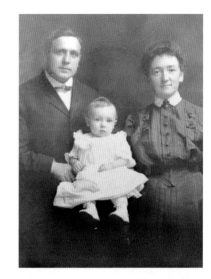

32

33

be the first. Fifty years later, in the heat of early second wave feminism, I considered changing my name to Lucy Stoner — not because I was a pothead, but to honor the Quaker woman famous for keeping her maiden name, and because I love stones and rocks.

By the time I knew my father's parents, Grampy had lost his job at the factory and had a little two-pump gas station near their home. I remember it primarily for its glass case of candy—Necco Wafers and Good & Plentys—which endeared me to my peers when I visited. His Cockney accent could be confusing. When he said that he "ighted the pipeists," I thought he hated people who smoked pipes until anti-Catholic prejudice was explained to me.

Encouraged by his family, my father decided to be a doctor, but his high school principal refused to recommend him to Yale "because nobody from Marlborough High goes to those places." Vernon had to ask the mayor, who was not as burdened with class anxiety. After a grueling college entrance exam at a nearby prep school, where he realized that private schools were taught a different logarithm system than public schools, he made it through by explaining the problem with each question. This story always makes me tearful. He got to Yale aged sixteen, writing decades later that "the adjustment of a poor small-town boy to life at Yale was difficult"— probably a huge understatement. But he was a letterman in Lacrosse (at 135 pounds, he couldn't play football as he had in high school).[34] He worked his way through undergraduate and medical school in seven years, wearing the one unfashionable suit his parents had sent him off with, graduating cum laude in 1929.

After Fitchburg High, where she was an excellent student and won a writing prize, my mother Peg graduated a French major from Smith College in 1929, having spent her junior year at the Sorbonne in Paris.[35] She collected one-liners from different languages and spoke good Italian too, mostly used to bewilder waiters in Italian restaurants. As a Congregational minister's daughter, a reluctant "church mouse," she found college liberating. Both my parents had scholarships. When I went to Smith in

34

35

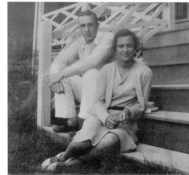

36

1954, I wanted a scholarship too, but my parents told me firmly that scholarships were for those who needed them and they had been saving for my education since I was born.

My parents met in New Haven, where Peg had a secretarial job at the Yale Medical School and Vernon was interning at the New Haven Hospital. Vernon William Lippard and Margaret Isham Cross were photographed on the steps of High Tide looking elegant on the brink of their fifty-four years together.[36] (My parents of course are now gone, and so are the family "step pictures," as the stairs were removed by my cousin Anne Cross Pelon who inherited the house.) Daddy is wearing his "hospital whites," acquired while he was an intern; they were replaced in 1945 by his army khakis, which lasted till his death, some forty years later.

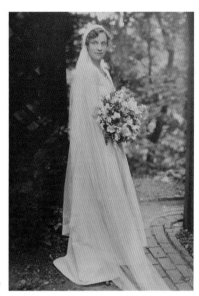

37

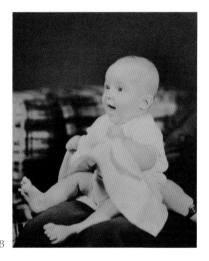

38

They were married by her father at his church [37] in Winchester in August 1931, honeymooned on Kennebec Point (as I did thirty years later), and moved to New York City. After his residency in pediatrics at Cornell's Nursery and Child's Hospital, my father worked briefly for a private pediatrician to the rich. Wanting to do more public good, after working in Hell's Kitchen and publishing a book on the crippled child in New York City, he found his mission in 1939 as a medical educator, becoming Associate Dean at Columbia Medical School. My mother worked as a secretary for a motley collection of bosses including a crooked antiques dealer (he couldn't pay her when she left and that's how we got our dining room table and chairs) and Leopold Stokowski's wife Evangeline of the Johnson and Johnson fortune, who sent my mother to the bank in an armored car with her outlawed gold ingots. In a 1940 letter to her parents, Peg wrote: "We've done quite a bit of dancing this winter — and how I love it! Vernon does too, and we're getting quite good, doing the Conga and the Rhumba and the Polka..."

I was born on April 14, 1937, at New York Hospital.[38] My doctor father's telegram to grandparents said I was a "fine specimen." My first memory is looking out from my crib through the screen door of my grandparents' cabin in Maine and hearing the seagulls' cries muted in the morning fog. When my parents had been married for eight years, they built, with an architect friend, a "modern" house [39] on Kennebec Point (with an ill-advised flat roof) that became

[28]

a significant place in my life. At age 86, this will be my 87th summer on the point.[40] (My first trip, at three months, was in a basket, on a boat.) My grandsons are the fifth generation to bond with Heal's Eddy and Sagadahoc Bay, Seguin and Pond Island Lighthouses, the Sugarloaves, Spud Walks, Wood, Salter's, and Stage Island, where indigenous people had camped and 16th and 17th century coastal fishermen had dried their catches before actual European settlement.

In 1942, the U.S. having entered World War II, my father enlisted in the Army Medical Corps with several of his Columbia colleagues.[41] My mother and I followed him to boot camp in Hingham, Massachusetts, and saw him off to parts unknown from the railroad station in Bath, Maine. During the war, Mother was Secretary to the Headmistresses Association and a secretary at the Lenox School, with free tuition for me, in kindergarten. (My 1941 report card noted that "her art work is particularly nice"; a few months later, I continued "to do interesting art work and she is doing very well in French" (at age 5?). I was supposedly too young to go into first grade, but my mother argued me out of another year of kindergarten, and on I went.

We received heavily redacted photocopies of letters from Daddy, as well as presents, like a little grass skirt for me that had been fumigated and fell apart on arrival. Families were not told where their men were stationed in the South Pacific, but one day there was a *New York Times* obituary for my father's tentmate, who died of a tropical disease; the exact location was noted. He wrote to my mother

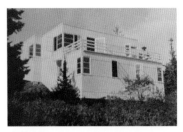

39

40

41

42

43

almost every day and these letters have survived, but hers to him have not, so I have been spared the details of three years of my childhood. Daddy wrote that life alternated between boredom and emergency. He began painting watercolors [42] to keep himself sane in the two years on South Pacific islands (Goodenough and Biak among them). Everything he painted thereafter, even the Maine coast, featured deep tropical greens. His unit moved constantly, building grass hut hospitals on various islands, co-existing with the Natives, whom the military callously called the Fuzzy Wuzzies,[43] thanks to their impressive Afros. At one point a battle hopped over the hospital and they found themselves behind the front lines.

◆

When news of the war's end in the Pacific reached Kennebec Point, a fleet of rowboats with lanterns glowing came down our bay. The next morning the Kahrl boys, whose family housed the community telephone, yelled up the hill from the beach something that sounded like "Vernon calling." I'd never seen my mother run down the hill and dash across the beach faster, but it turned out to be her sister in Vermont.

In the fall of 1945, a nice man in uniform turned up at our door, my mother was ecstatic, and life went back to something called normal. I grew up around art as my parents were Sunday painters and museum goers. In the 1930s they had taken a studio class at Cooper Union. My mother could draw and my father could paint, though now and

then they switched off.[44] While he was gone, my working mother and I looked at a lot of art, mainly in the Metropolitan, which was walking distance from our far-east-side apartment. After the war, in the Maine summers, we three went to beautiful places on the coast and painted (whiskey bottles of water, a tin box of watercolors, paper thumbtacked to cutting boards).[45] John Marin was a favorite as he had worked in our neighborhood, as did Marsden Hartley. After my parents died, I found two watercolors[46] they had painted side by side at New Harbor, Maine, in the 1950s. I framed them together. They might have been made in entirely different places — Maine and the jungle.

When my father returned from the war, he was restless and accepted the job of Dean of the Louisiana State University Medical School, which was in New Orleans. First we stayed with a colleague in the Garden District, then rented on Jeannette Place, then bought a stucco house on Neron Place with gardenias growing by the door. In New York my only pet for a while was a tiny painted turtle from the circus I named Hercules Ulysses Sir Van Domino Lippard, who disappeared forever behind a radiator. Later we had a black cat I named Forever Amber, but I had been asking for a dog and finally got one for my ninth birthday.[47] She was a shaggy red Cocker Spaniel named, yes, Little Miss Muffet, or Muffy, or the Muffalo. Sweet and smart, she chewed up only one book, pulled from a low bookshelf: *Simple Secrets of Dog Discipline*.[47]

44

45

46

[31]

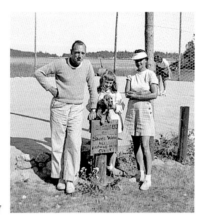

47

In New Orleans I attended the Isadore Newman School and made two close friends, both of whom had access to horses and open country, one of whom, Avis Fleming, became an artist and a lifelong friend. She lived in the mostly Cajun town Lafitte, on Bayou Barataria. I spent a heavenly summer there in the late 1940s when my parents were at Bellagio, Italy. We usually rode early every morning, and again at dusk, to avoid the heat. We learned to ride standing up, bareback, which was a feature in a circus Avis and I and her two older sisters put on for a nearby boy's orphanage. One day we were racing down a long field to escape a thunderstorm and we saw lightning strike and kill two horses standing in a pond.

New Orleans was a pleasant culture shock for us Yankees. Mother started working with "race relations" and got her first taste of the real South.[48] Four years later we got another taste when my father rejected a Senator's son's application to medical school because he didn't have the grades. Response from the political machine was going to

48

[32]

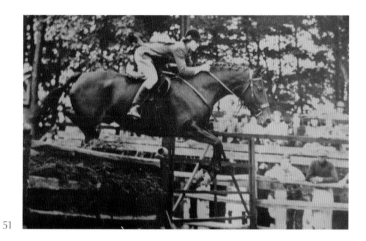

51

49

50

52

be prompt and he called the University of Virginia, where he had just turned down the deanship. It was still available. "We'll be moving," he told us. We would miss New Orleans, but horsy Virginia was an exciting choice for me.

As a kid during World War II, I listened religiously to the Lone Ranger radio show,[49] galloping around the living room to the William Tell Overture (unaware, of course, that the name of his sidekick Tonto was a racist slur meaning stupid in Spanish). This led to my horse-crazy period.[50] Actually, I learned to ride bouncing on a horse shaped oak limb in Maine, long before I mounted a live animal. In Charlottesville, I worked at Elliewood Keith's funky but legendary stable, smack in the middle of a residential neighborhood.[51] I got to break and train horses and ride in fox hunts and horse shows, to the bemusement of my family. In 1951

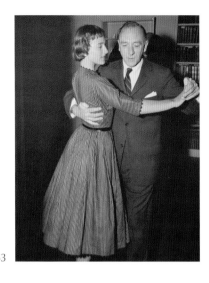

53

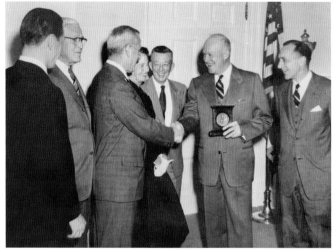

54

I sent a telegram to my traveling parents: WON BLUE
RIBBON IN VHSA 27 CONTESTANTS.[52] I went to Lane High
School and started tentative dating, though horses were
far closer to my heart than boys. When I turned up to work
at the stable one day wearing lipstick, Elliewood's eques-
trian star daughter Chee said, "well, there goes another one."

◆

We all loved Charlottesville[53] and our neighbors on Edge-
wood Lane, including my best friend, Juliet Hammond,
who came to Maine (where the other teens called her
"Southern Fried Chicken" for her accent) and came north
again to Smith. But when Vernon was offered the dean-
ship at Yale,[54] it was too tempting for that poor boy who
had long ago negotiated the ivied class system. We moved

to New Haven in the middle of the year so for the last two years of high school I was sent off to the all-girls Abbot Academy (later absorbed by Phillips Academy at Andover). It was something of a culture shock after the freedom and social diversity of Lane High. My summer boyfriend, Graham Wren,[55] who was at nearby Medford High, came every Saturday for "Calling Hour." We were not allowed to go outside, for fear of escapes to the bushes. But he was diligently punctual, so we usually got the alcove where a bit of privacy was open to firstcomers. At Abbot I made some good friends, and was encouraged to write by my English teacher, Miss Alice Sweeney, a classic New England "spinster" who lived with her sister. I took her interest seriously. Years later I was given an award by Andover, and she was there, saying she was deaf as a post and couldn't hear me, but she loved seeing me up there. I was given a medal

55

56

for *his* service, to the delight of the newly co-ed school. I spent very little time in New Haven, between boarding school, summer jobs and vacations, and eventually college.[56] But for the rest of my parents' lives, they were in pleasantly close reach, there to be proud of my accomplishments and to witness and tear their hair about my erratic love life.

When I graduated from Abbot, I wrote a letter to myself dated June 2, 1954, not to be read for five years. When it arrived, I recognized the childish handwriting but didn't recall writing it. My seventeen-year-old self wrote her expectations to her twenty-two-year-old self, who had met most of the criteria.

"Hi ya, Hon!... Out of Smith College (did you get booted or graduate?) and, I hope, off doing all the things you've always wanted to do..." [I expected to have] " gotten something published by now. I'll never forgive you if you've given up writing and painting by this time!" [I had given up painting and hadn't yet published anything beyond college.] "I hope you're still an individualist and love to argue and haven't gotten overly gushy or religious.... I hope it's still peacetime and that you aren't married or thinking of it yet. Remember, you were going to wait and live a little, experience some of the realities of life, and only then be ready to settle down...."

◆

As an only child and daughter of an avid reader, books were my best company. I decided around age twelve to be a writer (switching from rider), and in the 8th grade at Lane High I won $10 for the high school writing prize — a story about the Spinney brothers bootlegging on Bay Point, Maine during the Depression. (I bought a tennis racket.) I didn't major in English at Smith because I didn't want anyone to tell me how to write. But I took one fiction writing class from a delightful woman named Evelyn Page, who wrote mysteries under the pen name of Roger Scarlett. She told us we were allowed only one violent death a semester. (For neophytes, ending a story was challenging and violent death was the easy way out.) I have since lost a series of short stories I wrote then titled *Playing God*, which included the story of my father saving

a man from suicide only to read in the papers later that he had murdered someone. Another story was my grandmother watching from her porch as a neighbor's son with Down Syndrome waded out to sea in Maine and thinking, briefly, that it might be for the best, before running down to pull him back.

At Smith I lived in Haven House,[57] noted (though I didn't know it then) for also housing Sylvia Plath. At the end of my sophomore year, with my roommate 'Lyn Brown and two graduated seniors, I took off for a whirlwind road trip across the West, heading for the Pacific. The woman who had gotten a blue Buick for her graduation present was a humorless polio survivor,  a difficult character. We had made a bargain that we would sleep out and not stay in hotels, for economic reasons, and we did, among many adventures. Once we plunked our sleeping bags down at night and woke to find ourselves in the middle of a religious community. Another time we were surrounded by a cattle drive and were given breakfast by the cowboy herders. Somewhere else we slept in a field and at breakfast the next morning at a local diner were informed, with howls of laughter, that we had slept on Rattlesnake Hill. Yet another time, when it was raining outside, we ducked down in the balcony of a national park lodge after a music program, and slept on the benches, waking up to a Catholic mass taking place below. By the time we reached Banff, having given up on the Pacific and heading for Lake Louise, our car owner came undone and attacked us, to the consternation of a young Mountie. Kathy, the other senior, the responsible one, drove her home while 'Lyn and I were cast loose with our sleeping bags and a frying pan. At the counter of a Banff diner, where we were trying to figure out what to do, we got talking to an old cowboy who

57

58

59

ran the riding concession at Lake Louise. He said he'd help us out if we made it to the campground near there. We did, hitching a ride in a house that was being moved. The cowboys fed us and took us riding. A medical student and his wife camping next to us worried about our peanut butter diet and gave us canned vegetables. We had a great time for a few days and then set out toward home.

We had given Kathy postcards [58] to mail to our parents on her way home so everything looked normal, while we hitchhiked to Calgary, where we were befriended by an old German man who fed us. Finally, we got a bus across the Canadian plains, still surviving on peanut butter, ameliorated by kind passengers who sometimes brought us ice cream at stops. After a day or so in Montreal, with a memorable tour of a wax museum, we arrived in Connecticut in the middle of the night, called my puzzled parents, and finally got a real meal in New Haven, which made us sick as dogs. My legitimate postcards home are filled with superlatives about the mountains, hiking, climbing Pike's Peak, Yellowstone and Glacier, and the West in general. On one of them I said I was having "the time of my life," and I was.

◆

I was an art history major at Smith, mostly, I admit, so I could go to Paris for my junior year, following in my mother's footsteps. It had changed her life, and I was ready for a change in mine. After an introductory month in Aix en Provence,[59] I lived with the relaxed Duboucheron family on the Rue de Rivoli and was often recruited to help with

their business — folding city maps. They treated me and my housemate Lindsey Nathan as though we were adults, with less supervision than the college would have liked, had they only known. I was lucky to have as friends Pat deGorgorza, a Smith classmate who was already an artist, and her boyfriend, Swiss artist Dadi Wirz. They were print-making at Stanley William Hayter's Atelier 17, as was Werner Buser, [60] who became my own Swiss artist boyfriend. We spent some time in southern Spain and he later turned up in New York, eventually landing in Galesburg, Illinois, where he died in 2015 (but not before he came to Santa Fe in 1998 for the opening of my so-called collection, in-cluding his work, where we reminisced and went dancing). I was an avid bystander at Hayter's, returning to Smith to make landscape woodcuts under the tutelage of Leonard Baskin. [61] My parents framed the biggest one; it hung in their New Haven dining room and is now in Maine. Some-times it makes me cringe and in other less critical moments, I kind of like it. The messier *Storm at Sea* [62] is my favorite. As a populist (in the old-fashioned, pre-Trumpian sense), I was attracted to prints because they were more accessible in inexpensive multiples. After being complimented in a studio art class I thought maybe I should be an artist instead of a writer. I brought some paintings home to show my parents. They scrutinized them and said... "writer."

I recently unearthed a carton of letters that I wrote to my parents from Paris in 1956–57; single-spaced typed pages full of excitement, ranging from gushy to sarcastic. If this were a

60

61

62

real memoir, I would make myself read them all, as well as the report cards and bad jingles on handmade birthday cards. Some of them probably contradict what I have written here, based on memory alone. I've decided to let them rest. But I recently found an anonymous typed missive from Smith in June 1958, "Ode to Lippard":

"Away out the door she flew like a flash
With a twist of her tail and plenty of dash:
The girl who's adept at using her lip.
Some say she's in a class all her own.
Abounding with talent nurtured and sown
With hands and head in continual motion
What else could she choose but constant commotion..."

... and so forth. I have no idea who wrote it. Years later my performance artist friend Jerri Allyn called me Lucy the Lip, and I used it as a pseudonym for my feminist comics.

◆

63

The junior year in Paris was an art education and a life revelation. During my senior year in college, I often went to New York, staying on Washington Square with friends of my parents teaching at NYU. I began to go to galleries and see modernist and contemporary American art. After graduating in 1958,[63] I couldn't afford to get back to Europe, so on the advice of a friend's brother, I applied for a scholarship for a few months working with the American Friends Service Committee (forerunner of the Peace Corps) in the village of San Salvador El Verde, across the barranca from San Salvador El Seco, in the province of Puebla, Mexico. It was my first experience of the so-called Third World. I knew very little about Mexico aside from reading D.H. Lawrence, not the most dependable source.

El Verde was mostly the ruins of a gridded Spanish colonial town with a beautiful big colonial church. During the Gregorian chants of mass, an indigenous group played two kinds of drums and a flute-like *chirimia* in the vestibule — an extraordinary echo of historical culture clashes, or a tribute to cultural co-existence. We *Amigos* helped in the fields, taught English, and advised about washing dishes in boiling water, given the lethal toll taken on local babies by amoebic dysentery from polluted water. Another young woman and I taught "geography" to kids in an indigenous village across the arroyo. She had the brilliant idea of using illustrations from magazines to show them the rest of the world. (*El mundo es rondo!*) The students' Spanish was almost as bad as ours; the nearby market town of San Andres was the biggest place they'd seen.

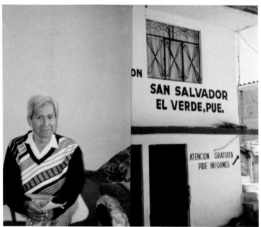

64

In the early 2000s, my partner and I were visiting Nancy Churchill and Leigh Binford, former students of his who were teaching in Puebla. I insisted on going to a much-changed El Verde, where I sat in the Zocalo and asked passersby if they knew Semei Morales, [64] my favorite teenager of some fifty years earlier. The third person pointed to his house and we had a sweet reunion, recognizing each other immediately. Thanks to the AFSC, he had taught English all his life, but he was dying of bone cancer.

The Quakers were good souls, but consensus was hard for a contrarian like me. Every morning we met on the roof of our ruin, with beautiful views of the looming Ixtaccihuatl volcano, to discuss the work of the day. I was fine with majority rule but

65

stubborn about agreeing with everything if I didn't. I must have been a royal pain in the ass. Years later I was at an anti-war demonstration in DC and ran into Aubrey Williams, who with his wife Becky and their small children had been our AFSC leaders in El Verde. When he recognized me, he said he'd never expected to find me there. I was insulted.

◆

Howard Devree, the *New York Times* art critic at the time, encouraged me to write about a print biennial in Mexico City, and critiqued it when I got back. I thought of getting a job at a Mexico City gallery; when I applied in person, they told me my Spanish was good "but very rural." These plans bit the dust when I went home to be a bridesmaid in the wedding of 'Lyn Brown and her Amherst love, Lee Follett.

I couldn't get back to Mexico and ended up in New York looking for a job in the fall of 1958.[65] My boyfriend, Lutz Prager, had graduated from Yale Law School and we liked drinking beer at the Bleecker Street Tavern (which boasted a very early Franz Kline mural behind the bar) — a kind of slumming, as it was mostly patronized by Bowery "bums," one of whom I fell for. I had the good fortune to land a job in the

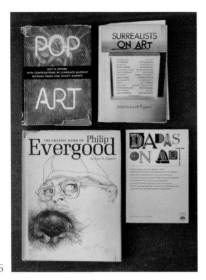

library at the Museum of Modern Art right after a major fire — not the glamorous art gallery spot I'd had in mind (I couldn't type fast and wasn't pretty or polite enough to be a gallery gal) but a far better opportunity. For a whopping $45 per week full time, I got to reshelve all the library's books, an education in itself, as was my regular job filing ephemera and indexing periodicals. Bernard Karpel, the learned and avuncular MoMA librarian, a Dada afficionado like me, encouraged me to get a library degree. (Marcel Duchamp once told Karpel that he should have been the Dada and Duchamp the librarian.) But I was determined to be a writer.

I'd been awarded the Mary Augusta Jordan medal for creative writing at college graduation and I wanted to write fiction and novels. Never happened. I couldn't write the kind of fiction I like to read: real narratives, with real characters. But my first year in the city, I religiously rose early before work and wrote what I considered commercial fiction, which was supposed to support me while I wrote serious stuff. I acquired standard rejection notices from *Redbook, Cosmopolitan*, and *The New Yorker,* among others.

Books are my favorite form, though they are incredibly unlucrative.[66] My other mentor at MoMA was Bill Lieberman, Curator of Prints and Drawings (later at the Met), along with his elegant assistant Elaine Johnson, who became an unlikely close friend. Bill passed on to me projects he didn't want, so my first real book was *The Prints and Drawings of Philip Evergood* (1966). Prophetically, for me personally, Evergood was a determined Communist well after the 1930s. I also did research and some French translations and interpreting. My next book, *Pop Art* (1966), was

67

68

commissioned by the owner of *Arts* magazine. I recruited Lawrence Alloway, Nicolas Calas, and Nancy Marmer to cover different aspects and regions. Jim Rosenquist, a pal, made a neon piece especially for the cover. I never profited from this book, but someone must have, as it was translated into several languages. In 1970 I published *Surrealists on Art,* and the next year, *Dadas on Art,* both with my mother's help translating from the French. I paid homage to my art historical favorites and then left them behind. By that time, I'd thrown in my lot with living artists, from whom I have learned most of what I know about art. But MoMA was under the illusion I would hang in for a museum career and they paid for classes at the NYU Institute of Fine Arts in the Doris Duke Mansion on East 78th street, quite a contrast to my Lower East Side digs on Avenue D.

At some point in those late 1950s, Lower East Side Beat Generation, or proto-countercultural days, I met an artist named Judy Gerowitz, whose then-husband was a writer. I often welcomed him into the library so he could enter the museum without paying. Over a decade later, as Judy Chicago, she was a founder of the U.S. feminist art movement, and we became co-conspirators. In the summer of 1960, I quit the MoMA job (the only real job I've ever had, thanks to my early acknowledgment of an authority problem) and went to Florence for an art historical intensive led by H.W. Janson — via Paris, where I hung out with artist Steve Rosenthal. I came home to freelance for various departments at MoMA.

My graduate school advisor was the deadpan "primitive art" historian Robert Goldwater, whose wife, the artist Louise Bourgeois,[67] was later to become a friend and inspiration. Institute students were not allowed to work for a living, as it distracted from studies (assuming class superiority and financial support). Goldwater busted me working in the MoMA Library. I told him if I didn't work I didn't eat, that I was living with an artist and so was he, so he should know the economics. He concurred with a wry smile. (I told the story years later at his funeral, where Louise had signed me up to speak ... without warning me.) In February 1962 I received my MA in Art History with a thesis on Max Ernst, ignoring suggestions that I should go on to a PhD. I wasn't headed for academia, and art writing was taking over as fiction ambitions faded.[69]

It was a later adversary, Hilton Kramer, then editor of *Arts Magazine*, who gave me very good advice in 1958 when I prematurely submitted some sappy reviews. He said I wrote well but should wait till I'd spent a season in the art world, discouraging me from writing about art until I knew what I was doing. A decade or so later Kramer, a conservative, wrote that I could have been a really good art historian but I "fell prey to the radical whirlwind." And I did indeed.[68, 68A]

In 1961 I published an essay on Max Ernst and Jean Dubuffet in *The Art Journal* and finally began to write and publish regularly, thanks in part to writer/artist Max Kozloff, who had also been in the 1960 Florence group. In 1964, he

and Barbara Rose were writing the "New York Letter" for *Art International* and they quit within months of each other. Max recommended me, and I wisely did not inform the Switzerland-based editor that I was very pregnant, which would have been a deal breaker.[74] I only missed one assignment; ironically, it was Anthony Caro, a favorite of Clement Greenberg, to whose dictatorial role in the then artworld I was vehemently opposed.

I had some mind-blowing experiences while I was working at MoMA. Once I was looking at a drawing of Marcel Duchamp hanging in the basement gallery, looked up, and beside me was the real Marcel. Then at some point I was sent to deliver something to him over on the far East Side. The label on the bell read Duchamp, Ernst, Matisse, enough to send an art freak into ecstasy. I went tearing up the stairs when admitted. How did you get here so fast? asked Duchamp when he opened the door. I was invited in. There were masterpieces on the floor, leaning against the wall.

I got to interpret from French (badly) for Joan Miró and Jean Tinguely. When Miró came into a room of his show at MoMA as it was being installed, he pointed to *The Farm*, which he hadn't seen in decades: "J'ai fait ca, moi!" he said with childlike glee. I worked with Max Ernst, whose English was much better than my French. He was old but still seductive, with bright twinkling blue eyes. He took me out for a drink and told the waitress, the lady will have a Blooody Maaary, making it a whole new and sexy beverage.

◆

After sharing with college friends a tiny apartment in the Village for a few months, I found my own community, paying key money to the addict nephew of Archbishop Cushing and claiming a room on 9th Street and Avenue A for $18 per month. It was a classic cold-water flat; the covered bathtub doubled as the kitchen counter, the bed was in a sort of closet, and the toilet in the hall was shared with a Puerto Rican seaman who used it as a beer-drinking refuge. I painted a rug on the floor, and temporarily adopted a cat who arrived via the fire escape and had kittens in the fireplace, which I'd cleaned out, though never used, for fear of burning down the building; it was stuffed with WWI newspapers and a Doughboy whiskey bottle.

We had a sort of urban commune: A sweet guy from the Catholic Worker lived upstairs, and he had a stove. I had a phone. The expert shoplifter next door, single mother of a little girl named Dylan, had nothing practical, but she read Joyce aloud with a wonderful Irish accent, so that was her contribution. She ended up on the run with her steamboat captain partner for what must have been one of the earliest credit card scams, and lost a baby in Mexico. Years later I ran into her on the street in New York — probably back home incognito — and she refused to recognize me.

It was the era of the 10th Street galleries, which I haunted, and the Cedar Bar, which intimidated me. I was a bundle of energy, never cool, wanting too much to be liked. My boyfriend at the time was a chess player and Zen Buddhist; he had signed up for another tour in the Navy in order to go AWOL and make a peace protest. In the meantime, he was a Bowery bum waiting to be nabbed. It took them over a year to track him down and put him in a mental ward. I joined my first New York demonstration with Ammon Hennacy, comrade of Dorothy Day at the Catholic Worker, protesting the projected Lower Manhattan Expressway, which happily was canceled. I was no Catholic, but friends, who were, introduced me to oppositional politics.

◆

In fall 1958, at the celebration of MoMA's post-fire reopening, I met Robert (Bob) Ryman, a softspoken jazz tenor sax player from Nashville, Tennessee, a descendant

70

71

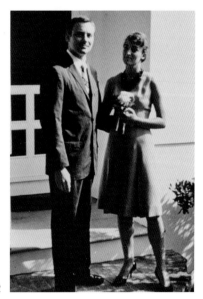

72

of Tom Ryman, a riverboat gambling captain who built the tabernacle that became the Ryman Auditorium and went from praise of Jesus to praise of Country music.[70] Bob had studied informally with Lennie Tristano, Warne Marsh, Bill Evans, and Lee Konitz.[71] After several years of staring at art as a guard at MoMA, he became a painter, and eventually an extremely successful one, known for his unexpectedly varied white paintings.[73] In the fall of 1960, he had moved on to work as a page in the art section of the New York Public Library, where we reconnected. After I was stalked by an ex-con with whom I'd been involved, I moved in with Bob on 10th Street and Avenue A. Then we moved to a sixth-floor walkup on 7th Street and Avenue D, where you knew a robbery was taking place if there was a small boy sitting on the stairs as a lookout. When they broke through

the police lock on our door, they of course found nothing of value (my typewriter was hidden in the bathtub under a cover of dirty dishes). In a rage, they scattered my "jewelry" — plastic Pop It Pearls — all over the apartment.

To my parents' relief, Ryman and I were married [72] on August 19, 1961, in front of the fireplace in the house on Kennebec Point, witnessed only by my parents, my aunt Eloise Cross, and my grandmother. I wrote the very brief ceremony and an old family friend, congregational minister Daniel Bliss, who married us, didn't bat an eyelash when I said God was not to be mentioned; he even scissored out divine mention in the marriage license, noting with a twinkle in his eye that God would be there anyway. The whole community arrived afterwards for a reception on our deck. With my short pea-green wedding dress, I wore black jewelry, which someone said was bad luck.

Bob and I moved to a loft at 163 Bowery — $65 per month, down from the asking price of $75 which we could not afford; the landlord was not yet aware of the demand for artists' lofts, or perhaps he just felt sorry for us. Around 1961, Bob and our friend Ray Donarski were exploring a vacant loft down the Bowery and found a mounted trophy buffalo head. When I came home from work, exhausted, they gave me a drink and waited for me to notice the creature on the wall. Bonzo [75] has been with me ever since. (Actually, he's probably a she, or a calf, since the massive head is small for a full-grown male.) Later I told my son's little friends that he was a Vanishing American Bison and

73

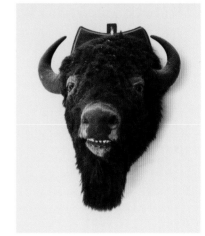

75

the rest of him had vanished (or was on the other side of the wall). The loft above ours was a button factory and we got used to the daily rhythmic pounding over the dining table. [76] We took advantage of it when Bob and I and Donarski made a button to commemorate the Mona Lisa's 1963 visit to the Met and hocked them outside the museum.

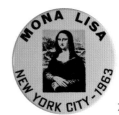

76

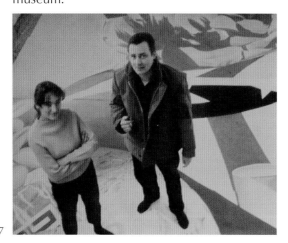

77

Partly through Bob, who was friends with Dan Flavin, Takeshi Asada, Sol LeWitt, and other artists, I was increasingly involved in the art world. [77] Jim and Mary Lou Rosenquist, June Leaf and Joel Press, Jo Baer and Jack Wesley introduced me to very different aspects of this complex arena. Eva Hesse and Tom Doyle lived a block down the Bowery. Sol was nearby on Hester Street and at the night desk at MoMA; he read French *nouvelle vague* novels from the Donnell Library across the street, passing them on and influencing others, including me — the first of many contributions over the years from this extraordinary artist and generous friend.

I never was much of an art historian. By then I knew that I was far more interested in art that was making history than in history already made. In the mid-to-late 1960s, my "formalist period," I was writing for *Art International, Arts, Art Journal,* the *Hudson Review, Artforum*, and occasionally for *The New York Times*. I was becoming an art critic, like it or not. I dislike the term as I've always been an advocate, not an adversary. I describe myself as a writer, activist, and sometime curator. I write about what I like,

[50]

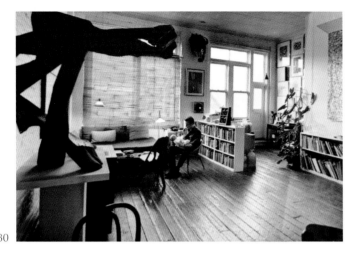

80

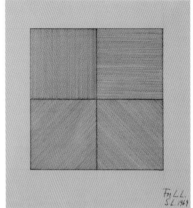

78

saving my criticism for capitalism. [79] Nevertheless, in 1971, at the invitation of Gregory Battcock, my first collection of essays appeared, titled *Changing: Essays in Art Criticism*. [78] LeWitt's cover drawing was a literal image of change, its possibilities... and limitations.

◆

Our son Ethan Isham Ryman [80] was born by the Lamaze method of natural childbirth in New York Hospital, where I was also born. When the contractions began, we were lucky, very early in the morning, to catch a cab willing to stop on the Bowery and take a panting mother-to-be on board. Ethan arrived on December 4, 1964, my grandmother Florence Cross's birthday, which she took calmly as her due. Ethan inherited her charm and her way with people. Her husband Judson had died in 1947, and almost until her death in New Haven, in Summer 1965, she split her time between her three children. I was regaled with stories of her western childhood which made a deep impression

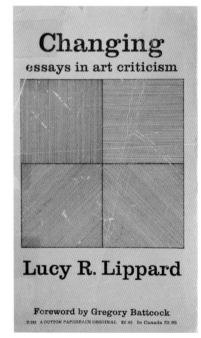

79

81

82

and were partly responsible for my eventual move to New Mexico, via Colorado, her youthful home.

Once Ethan was ambulatory, the loft looked like we were raising sheep, with fences to keep him away from my desk and Bob's paints.[81] Our years on the Bowery were fertile and enriched by new friendships. Robert Mangold took my job as page at the MoMA Library, and he and Sylvia Plimack, both painters, rented the loft above us. Their son Jimmy was born before Ethan, so we got all his hand-me-downs. (Decades later, unbeknownst to me, James Mangold, now a Hollywood director, drove past my New Mexico home daily to reach a nearby movie set for *3:10 to Yuma*.) I was working with Kynaston McShine on a MoMA show that became the landmark *Primary Structures* when he took it with him to become a curator at the Jewish Museum.

Another tenant at 163 Bowery was Frank Lincoln Viner. Inspired by his funky use of textiles for sculpture, and Hesse's groundbreaking work, I curated a show called *Eccentric Abstraction* in October 1966 at the Fischbach Gallery, where Donald Droll was director. I was looking for more sensuous alternatives to Minimalism; as it turned out the show predicted elements of feminist art. The artists were Hesse, Viner, Alice Adams, Louise Bourgeois, Bruce Nauman, Keith Sonnier, Gary Kuehn, and Don Potts. Around 1965, on her return from Germany and close to splitting up with Doyle, Eva and I became close.[82] (Ethan can brag that she was his sometime babysitter.)

I had met Ad Reinhardt briefly in Paris in 1960.[83] His art,

[52]

his humor, his ambivalent take on the artworld, and his left politics made a big impression. In 1966, still in my twenties, I was surprised and pleased to be asked to write the catalogue for his first institutional solo show, at the Jewish Museum. With his usual critical humor, he wondered what the hell I was doing with *Eccentric Abstraction*, given his dictum that "art is art and everything else is everything else." At his untimely death in 1967, at age 53, I was planning a book on him, with his blessing.[84] Robert Motherwell called and told me to apply for a Guggenheim fellowship. I said I was too young, and he said, apply and you'll get the one Ad would have gotten and you can write the book. $7,000 was a fortune for me at the time. Publishers were unenthused, but it finally came out in 1981.

83

◆

Bob's career started to take off immediately after I left in 1966 to take up with John Chandler[85] — an ABD (All But Dissertation) for a PhD in Intellectual History from the University of Chicago — whose family were Mainers. He and his then wife were running the general store in Georgetown. The relationship with John only lasted a couple of years but Ethan and I spent time with him one winter in Presque Isle, Maine, where he was teaching. I snowshoed over the potato fields and learned some philosophy. Ethan was efficiently potty-trained by his babysitter, along with her daughter, in a military household (a few slaps with a plastic spatula did the job; my parents were appalled). Together John and I wrote an article on "The Dematerialization of

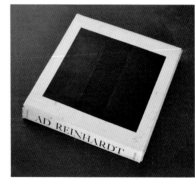

84

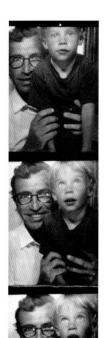

85

Art," published in *Art International* in February 1968. John was drawn into the artworld for much of his later career and then became a playwright.

Bob and I divorced in 1968. Ethan and I occupied the little apartment on Grand Street that he had just remodeled. He kept the Bowery studio, and for a while I paid his studio rent, feeling guilty about leaving. He was soon happily married to artist Merrill Wagner and they gave Ethan two beloved half-brothers Will and Cordy Ryman, both successful artists today. She and I realized there was no word for our relationship so for a bit we called each other Cousin (or C'un), inspired by southern tradition.

Ethan was a hyper lively, outgoing, and perceptive kid.[86] At an early age he was walking with me in the neighborhood on a Sunday morning behind some dressed-up people. I told him they were going to church and tried to explain God. He thought for a moment and declared "Before I was born I was God." Startled, I asked him how come? "God is invisible and I was invisible..." Another time we drove by some homeless people and again, my explanation was unsatisfactory. "Why don't they divide up all the money and give them their share?" asked the potential socialist. I said it hadn't worked so far. "Well then, why don't they change money into something that everyone has a lot of?" Because I could rarely afford babysitters, I dragged Ethan to endless studios and galleries.[87] When he complained, I told him, "This is my life and yours is coming." (I stick

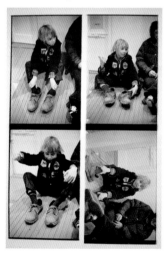

86

by this theory of single motherhood.) One night around age sixteen, Ethan came in stoned, way past curfew, and announced that his life had come.

◆

When Martin Luther King Jr. was assassinated on April 4, 1968, I was at a performance venue on Avenue C with painter Willard (Pete) Tangen and curator Kynaston McShine. When the tragedy was announced, Kynaston left to go to Harlem. We offered to come, but he obviously didn't want to be around honkys at this time of grief and rage. Politics were beginning to breathe down my neck. The anti-Vietnam war movement and conceptual art, then feminism and women's art were the transformative experiences that made me what I am today — a ranting old lady, and proud of it. One event was a major step in this trajectory. In August 1968 I co-juried a show at the Museo de Bellas Artes in Buenos Aires with Jean Clay, editor of *Robho*, who was just off the Paris barricades. It was a contentious visit as we refused to do the bidding of the exhibition's corporate funders. But when we were free of obligations (and they had canceled the last dinner party, after our outspoken press conference), with the help of Jorge Gluzberg, we met Graciela Carnevale and others in the Rosario group — artists who were collaborating with striking workers in Tucaman. It was the first time I'd heard artists say they wouldn't make art until the world was a better place. This deeply impressed me.

87

I went on alone to Lima, Cusco, Machu Picchu, and other amazing Inca sites, on foot and hitchhiking (once on a donkey).[88] Fifty years later, these memories surfaced when I wrote the texts for photographer Ed Ranney's books on the Nazca lines and *huacas*.[89] I was introduced to him by New York friend Cesar Paternosto, painter and scholar of Inca stoneworks, the beginning of a fruitful collaboration. Returning to New York a converted lefty, leaving my parents' liberalism behind, I co-curated

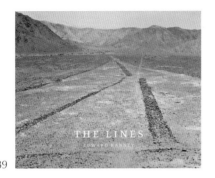

(with artist Bob Huot and Socialist Workers Party organizer Ron Wolin) a benefit show for the anti-war Student Mobilization for Youth at Paula Cooper's brand-new gallery on Prince Street. It consisted of major minimalist art accompanied by this statement:

"These 14 non-objective artists are against the war in Vietnam. They are supporting this commitment in the strongest manner open to them by contributing major examples of their current work. The artists and the individual pieces were selected to represent a particular esthetic attitude, in the conviction that a cohesive group of important works makes the most forceful statement for peace." On its 50th Anniversary in 2018, Paula recreated the show at her Chelsea gallery.

◆

That fall of 1968, I moved with soon-to-be-four-year-old Ethan to a co-op loft building at 138 Prince Street,[90] thanks to Donald Droll, who convinced me (and my father) that it would be stupid not to take advantage of this opportunity. He was so right — one of the few practical decisions of my life. The price was around $5,000, which I had toborrow from my parents. (Don't ask what the Family Mansion is worth today. Ethan still lives there and my grandsons were raised there.) We moved into Prince Street the day the longtime furniture finishing workers moved out, meeting them going down in the freight elevator. We lived for over a year amid blackened walls, encrusted floor, a toaster oven and hotplate, no plumbing, bedrooms defined by book boxes. Alex and Ada Katz[91] and their son Vincent were next door, through a then-open archway, and offered their facilities. I got sick of the mess and was thinking of selling the loft when my artist friends Pete Tangen and Hank Pearson[92] helped me paint it white. Suddenly the space was transformed, and it was home for another twenty-five years.

When the arch to the Katzs' was finally filled in with bricks, LeWitt made one of his first wall drawings on the lumpy surface.[93] Other building neighbors were Donald Droll and Roy Leaf, Al Held and Sylvia Stone, Steve Antonakos and Naomi Spector, and John Button. Some remain, though over the years there have been deaths and many changes. For years, the FCUK clothing store at street level paid a gigantic rent. Most (pre-pandemic) years, unless the

93

94

95

money was necessary to keep our pre-Civil War brick building upright, all tenants got a cut, which Ethan and I used to maintain the Maine house.

After pre-school at the Educational Alliance, on the Lower East Side, which was free if I helped out a couple of days a week, Ethan went (appropriately) to the Little Red Schoolhouse and then to Elizabeth Irwin High School, all funded by Bob, whose art was beginning to attract attention. Also in elementary school, Ethan's involuntary familiarity with contemporary art seems reflected in his giant *Hamburger*, complete with spider. I liked to think that all those reluctant gallery visits paid off and this was an involuntary homage to Claes Oldenburg.[94,95] Through Frank Correy, the father of his best friend Eric, at Little Red, Ethan made TV commercials for a few years for Honeycomb (that's the cereal with the "big big bite"). The first time I took him to a filming they told me I had to stay there too. For pay? I asked. No. Well, I work for a living, I said, and the only Black kid's mother kindly said she'd keep an eye on Ethan.

◆

In January 1969 the Artworkers Coalition (AWC) was formed, initially focusing on artists' rights, and I enthusiastically joined up.[96] We protested MoMA and the Metropolitan, the war in Vietnam, racism, and eventually sexism too. The museums tied us up in meetings to discuss our demands without doing anything, and most of us were hard put to waste time with art, jobs, children, etc., but we kept at it. At one point, they chose Robert Rauschenberg to counteract

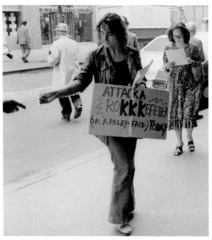

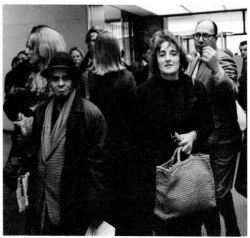

us, as another artist, but he took our side. The AWC was unstructured, no member-ship, the committees were basically autonomous. To tempt people to one meeting we sent out a card announcing a plan to kidnap Henry Kissinger. The FBI showed up.

Later in 1969 the AWC evaded guards and broke into a trustees' dinner at the Metropolitan Museum,[97] which had closed one wing for the event during Christmas break, infuriating visiting art scholars. One artist released cockroaches on the table "to keep Harlem on your mind," referring to the museum's ill-advised 1969 *Harlem on My Mind* show (organized by white folks with little or no input from Black photographers or Harlem itself). The museum's main doors were closed so we criminals couldn't escape. We were flashing cameras, mostly empty of film, but photographer Jan van Raay (very pregnant at the time) took real pictures, tricked the guards into confiscating a blank film, then casually left the scene. Her photographs have become iconic. The rest of us were rounded up and herded into a room to be arrested, but when no cops showed up, we just left. In the process an informer from the AWC (who always wore a vintage telephone dial

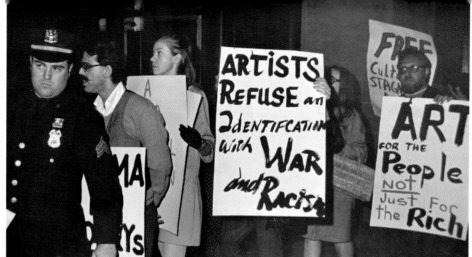

99

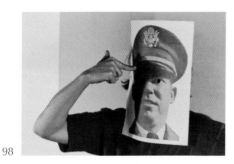

98

around his neck) was exposed when a Met official accused him of failing to warn them of our action.

On one of my bookshelves is a "War is Over!" political button painted by "socialist formalist" and political activist painter Rudolf Baranik. (Rudolf was a Lithuanian Jew and my artist friends Ad Reinhardt and Kes Zapkus were also Lithuanian. Once at a cocktail party in Chicago, a woman came up and told me firmly, out of the blue, that she *knew* I was Lithuanian.) In 1968 I met Rudolf walking his dog Sparta. He and his wife, artist May Stevens, lived around the corner on Wooster Street. They both became close friends. May was a powerful feminist ally, while Rudolf was a leader in virtually every art activist campaign, including the 1967 Artists and Writers Protest against the war in Vietnam, which preceded the Art Workers Coalition[98]

Soon after we met at the AWC, fellow activist and genius conceptual art entrepreneur Seth Siegelaub moved in with me,[99] accompanied for a few months by his little son Yves LeBlanc. A former dealer in rugs and art, Seth invented the distribution system that pretty much defined Conceptual Art with his gang of four artists:

[60]

Doug Huebler, Robert Barry, Lawrence Weiner, and Joseph Kosuth. We shared excitement about the rise of a "dematerialized" art in Europe and North and South America that for a while bypassed the conventional career path (group show to solo show to critical attention to gallery representation and museum collections), creating a whole new trajectory for artists less involved with objects than ideas. While LeWitt's Minimalist sculptures and wall drawings were not truly "dematerialized," the ideas that formed them were paramount. With Seth's help I curated the first two of my four "card shows" of Conceptual, Minimal and Land Art in Seattle (*557,087*, 1969) and Vancouver (*955,000*, 1970). Two more, were in Buenos Aires (*2,972,453*, 1971) and (all women) at Cal Arts in Valencia (*c.7,500*, 1974). The unmemorable titles were each city's current population.[100]

In 1969 I signed on to a conceptual artists trip to Inuvik, in the Arctic Circle, as a photographer (which I was not, thereby irritating better choices). But fellow travelers were some of my gang: Lawrence Weiner and Canadian Iain Baxter (half of the N.E. Thing Co.) who made ephemeral pieces on the McKenzie River and in the tundra. I wrote it up for *Canadian Art*.[101]

◆

In the early 1960s I had bought (paying on time) a print portfolio that included Franz Kline and other major artists. In 1970, I sold it so I could take off for Europe with Ethan, who had just turned five. We stayed for a week in Paris with Seth and then took a train to spend a few months in

100

101

102

103

104

Carboneras, Almeria,[102] on the Mediterranean coast of Spain, where Jean Clay had offered me his little house in the off season. It was still Franco's Spain. Ethan almost got us in trouble during the train trip down when he called the Civil Guard's patent leather hats *feo* (ugly). The little white stucco house faced a pristine beach and fishing jetty. (Today it overlooks a desalinization plant and a refinery.) We walked in the dry hills and climbed the beach cliffs. A local girl named Juana took Ethan to her home in the mornings, where he effortlessly picked up Spanish, and I wrote the first draft of an almost unreadable experimental novel, *I See/You Mean*.[103]

Spanish-speaking friends visited: Anne Twitty and her small son Gerardo Maza and then Susana Torre, an Argentine architect who had lived beneath us on Grand Street with her then-husband, sculptor Alejandro Puente. After I'd left Carboneras, Susana bought land north of the village from a producer of *Lawrence of Arabia* who remained in the village after the filming ended. For thirty-five years it was unbuildable, thanks to a newly established coastal boundary. When this was finally lifted, she and her husband, writer Geoffrey Fox, built a stunning condo complex on the edge of the Mediterranean. We still return to Carboneras for visits.

While Ethan and I were in Spain all hell broke loose at home — Kent State, Jackson State, the Vietnam non-war spreading illegally to Cambodia. (Years later I wrote a book/catalogue called *A Different War*[104] that included work by veterans and Vietnamese artists as well as protesters.) While

105

106

107

we were gone, Eva Hesse died of a brain tumor, probably from the effects of the latex she was using to create some of her breakthrough work.[105] (Sol, her best friend, immediately instigated a book on her, which I wrote; it was published in 1976.)[106] I got back to NYC in time to see the groundbreaking *Information* show at MoMA, curated by Kynaston McShine, who had joined me and Bob on our honeymoon in Maine. I wrote an experimental essay for the catalogue that baffled MoMA's scholars and, in retrospect, baffles me. Under the influence of conceptual art, I had begun to publish short experimental "fictions." As I write, they are being collected to be published as *Headwaters*, by Jeff Khonsary's New Documents, fulfilling a high school dream.

In 1973 I published *Six Years: The dematerialization of the art object from 1966 to 1972....*[107] (and on and on... a 96-word title) in homage to the deep impression made

on my work by Minimal, Conceptual, and political art. It was peculiarly organized in chronological/bibliographical bits and pieces, a relic of my curtailed librarian career. I was attracted once again to an artform available to a broad audience. Though conceptual art never fulfilled its populist promise, it transformed aspects of the avant-garde. In 2012–13, Catherine Morris, curator of the Sackler Center for Feminist Art at the Brooklyn Museum, organized *Materializing Six Years: Lucy R. Lippard and the Emergence of Conceptual Art*, giving me more credit for that emergence than I deserved.

◆

Writing *I See/You Mean* (later revamped as feminism crept into it, finally published by a feminist press in 1979), had brought home to me the fact that I was not one of the boys. So when I returned to New York from Carboneras I was ripe for a rapid (and rabid) conversion to feminism, which came late to the art world. I had previously resisted it when a group of AWC women created WAR (Women Artists in Revolution) in 1969, but now I joined Poppy Johnson, Brenda Miller, and Faith Ringgold to form the Ad Hoc Women Artists Committee. Our protests at the runup to the opening of the 1970 Whitney Annual, and during its full run, resulted in a lot of press and the addition of more (but never enough) women to the exhibition. At the opening, with the help of Kes Zapkus and Mark di Suvero, we projected slides of women's art on the museum façade[108] (until it rained and we were afraid we'd be electrocuted by the generator, which I'd managed to plug in at a gallery next door, to the bewilderment of its staff). We entered with fake invitations, and when that was exposed (cheaper paper) we gave our fakes to well-known artists who would not be denied entrance. Once in, we did a sit in. For the duration of the show, we were a presence, protesting at the easily blocked bridge entrance, blowing whistles in the stairwells, distributing eggs (white and black),

108

109

110

111

lipsticking the women's room mirror, leaving around un-used tampaxes labelled "50% Women," and leading a fake docent's tour. Our forged museum press release touted a representation of 50% women and "non-whites." We had been told it was not libelous but hadn't been warned that it was... if the director's and other proper names appeared. As a result, the FBI visited the organizers, starting with Poppy, the youngest at nineteen. She asked them if she had to talk to them; they said no, and she warned us. Nothing scared us. We were off and running.[109, 114]

In April 1971, I curated what was probably the first American museum show of women artists of "second wave" feminism at the little Aldrich Museum in Ridgefield, Connecticut. Susana Torre designed the catalogue for *26 Contemporary Women Artists*,[110] which was sealed, so to open it you had to "violate" it. To help me narrow down the huge field, I limited the show to those who had not

112,113

114

115

yet had a solo show in NYC (among them, Alice Aycock, Susan Hall, Sylvia Plimack Mangold, Mary Miss, Howardena Pindell, Adrian Piper, Merrill Wagner, and Jackie Winsor). West Coast feminists Judy Chicago and Mimi Schapiro of the Feminist Art Program at Cal Arts, who were organizationally way ahead of New York feminists, came to see it, along with *New York Times* critic Grace Glueck. I had resisted the California notion of an identifiable "women's art," but as Judy and Mimi triumphantly pointed to one piece after another to prove their case, I began to succumb, made clear in the title of my 1976 book *From the Center: Feminist Essays on Women's Art*,[112] followed in 1995 by *The Pink Glass Swan: Selected Feminist Essays on Art*.[113] At lunch that day we founded WEB (West East Bag) — a multi-sited newsletter with which we recruited feminist artist organizers around the country. In 2022, the Aldrich resurrected the exhibition as *52 Artists: A Feminist Milestone*,[111] adding 26 far more diverse young women/woman-identified artists who had not yet had solo shows.

Another big event that year was the Guggenheim Museum's cancellation of AWC co-founder Hans Haacke's show on natural and social systems. One piece took on absentee slumlords on the Lower East Side. The Guggenheim took their side rather than the artist's; curator Ed Fry was also fired. We protested with a NO MORE CENSORSHIP conga line up and down the famous spiral ramp, led by choreographer Yvonne Rainer.[115]

In 1972 Charles Simonds [116] and I got together, and our relationship lasted almost nine years. We remain friends, and family. Lia Simonds, his daughter with his ex-wife (art historian turned florist Bella Meyer) is my godchild, and I consider their son, artist Timmy Simonds, [228] an informal one. In summers, Charles and I sailed our little plastic bathtub toy of a boat up the coast of Maine, usually camping on land (and then in a larger sailboat named Phalarope after a feminist bird living far out at sea). [117] Closer to home we sailed with my father, who loved it. My mother demurred, saying she was either bored to tears or scared to death. Charles and I planned a sailing trip around the world, with no illusion that we would really be able to do it, but we had a lot of fun perusing maps. After my father's death I traded in the Lugger for a 12-foot, gaff-rigged catboat called Rosita[118] (after Rosa Luxemburg and a disappeared Central American woman).

116

117

118

With Charles, I got an education in community arts. He worked on the streets of Loisaida (New York's Lower East Side) making erotic clay landscapes and southwestern-pueblo-like dwellings of tiny bricks inhabited by an invisible Little People, in niches in abandoned buildings, window ledges, even gutters. Neighborhood children, mostly Black and Puerto Rican, identified with the Little People. Charles worked with the organizers of Mobilization for Youth to create La Placita (aka Charles' Park),[119] in a vacant lot on East 2nd Street between Avenues B and C.

119

**Cracking**

*Charles Simonds and Lucy R. Lippard*

120

121

TIMEANDTIMEAGAI

122

Simonds' dwellings, which were unlike any other community or public arts, struck a chord with these disenfranchised populations, as they did later with North African refugees in Paris and even crowds on the streets of Beijing. One of his dwellings survives in a stairwell of the former Whitney Museum on Madison Avenue, where it once faced another on a window ledge across the street. Simonds' complex philosophy for these haunting miniature "ruins" has been the subject of several little books, one of which — *Cracking* — we did together.[120] To accompany his images, I wrote a fictional account of a woman archaeologist who falls in love with an earth spirit and ends up underground.

Charles also introduced me to New Mexico. In December 1972, with Ethan, we went for the Shalako ceremony at Zuni Pueblo, but also slept out (and froze) at Chaco Canyon and went to other pueblo dances.[121] At one of them, we watched the first rays of sun enter the mission church as mass was superseded by pueblo dancers, reminiscent of my Mexican experience. I was smitten. We returned a couple of times in the next decade, watching the fields around Santa Fe where we had camped fall to development. I would have moved to the Southwest then and there, but I knew I couldn't make a living writing about art in New Mexico, one of the poorest states in the union, with a leading art market, but not for my kind of art. The dream lingered, and in 1992, I made the move. Many years later, I gave a slide talk on art and archaeology in the maintenance area at Chaco, and in 2013 I wrote the text for

[68]

Peter Goin's *Time and Time Again*,[122] on Chaco and Mesa Verde to accompany his perceptive rephotography. My dream of having a book in the Chaco visitor's center was fulfilled, though now, I'm told, it's gone.

◆

In 1974, I accompanied the travelling MOMA exhibition "Some Recent American Art" to New Zealand and met the artist/anthropologist couple Bruce and Pauline Barber, artist Ti Parks, writer Wyston Curnow, and artist Jim Allen, who took some of us, including American artist Mel Bochner, for a memorable trip to Rangitoto in his big sailboat. I rented a car and travelled alone around the South Island, amazed at the variety of landscapes, like miniatures of the American West. I slept on beaches and got a horrendous syphilitic-looking cold sore that made me a pariah at local bars. The next year,[123] I was asked to travel around Australia to give the Power Lecture (apt, but it was a proper name) that took me all over the huge country talking about women's art in the wake of the previous speaker, Clement Greenberg. I met a number of terrific women there, among them artists Vivienne Binns[124] and the late Annie Newmarch.[125] Annie was staying with me in NYC at the time of Colab's landmark Times Square Show and contributed to it. I wrote a review under the pseudonym Anne Ominous. Those were…those days.

◆

The mid 1970s was a time when I couldn't sit down at a kitchen table with co-conspirators without another group

123

124

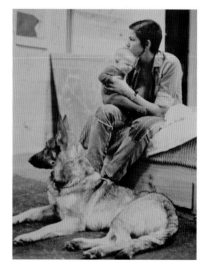

125

126

127

128

being formed. Around 1976, Sol LeWitt came up with the idea of distributing artists' books (books as art, made by artists, not to be confused with books about art). Discussing it at my Prince Street loft over his book-laden coffee table, we formed Printed Matter, bringing in at the onset Mimi Wheeler, Walter Robinson, Edit DeAk, and Pat Steir. Working at first from a room on Hudson Street, we decided to become a bookstore, while feminist artist Martha Wilson at Franklin Furnace took on the artists' books archive. We rented a storefront on Lispenard Street,[126] and I had a field day for a few years organizing the big double windows with commissioned artists projects. Printed Matter grew far past anything we had ever imagined and is now a vast store on 11th Avenue with an annex on St. Marks Place, as well as the organizer of huge national and international artists' book fairs.

Around the same time, we — a group of progressive and socialist feminists — got together at another table and formed *Heresies: A Feminist Publication on Art and Politics,* after a year of open meetings. The initial "mother collective" was some twenty women, including Joyce Kozloff, May Stevens, Elizabeth Hess, Harmony Hammond, Joan Braderman, Mary Miss, Mimi Shapiro, and Michelle Stuart, among others. I think nine of us were noisy, bossy Aries, like me. I met Hess, one of them, now author of several important books and a film on animal welfare, with her husband, film critic Peter Biskind, when they were editing the lefty magazine *Seven Days* and I was briefly their art

129

critic. The first issue of *Heresies*,[127] pasted up in May's studio with Rudolf running up and downstairs for supplies, came out in January 1977. Each themed issue was edited by a new volunteer collective with some of the "mothers" included. I worked on several and loved every minute of the contentious and educational process. Writing for a feminist audience instead of the conventional art magazines gave me license I didn't know I needed, to say what I thought.[128] I was so empowered that I briefly considered selling my feminist comics on the street corners.[129]

[71]

130

131

132

In the Bay area, the late Moira Roth — much loved art historian, feminist and multicultural scholar, whose artform was friendship — and social practice innovator Suzanne Lacy became particularly close friends and allies, along with old pal Judy Chicago. When I stay with Suzanne, now in Venice (California), I always want to go to thrift shops; she (who buys new and has her own distinct style) says "just shop my closet." I have literally been in Suzanne's shoes/boots on many occasions.[130]

I'm a loyal friend, to a fault. I hate it when my friends don't like each other. As an only child, whenever we moved, I found a "best friend," with whom I always stayed in touch, though of the five most important from childhood years — Frannie Wren (Raymond) in Maine, Avis Fleming (Hodge)[131] in New Orleans, Juliet Hammond (Hetzel) in Charlottesville, Diana Long (Hall/Patton) in New Haven, and 'Lyn Brown (Follett) in college — only 'Lyn and Avis survive today. I've always had close women friends and of course the feminist movement multiplied and intensified activist friendships, especially within the Heresies Collective. Harmony, May, Sabra Moore, and I all ended up in Northern New Mexico. Betsy Hess replaced me at the *Village Voice* and eventually moved to the Hudson Valley (decades before it was overrun during the pandemic) becoming a significant force there for animal rights.[132] She and Peter visit almost every summer in Maine where we jabber, sail, and eat lobsters while Peter advises my teenage grandson Calvin Ryman, who has begun to work in the film industry.

◆

Gnasher was a beloved cattle-herding Border Collie,[133] my constant companion when Ethan and I lived for a year (1977–78) on Ashwell Farm in Devon, near Totnes, England. Charles was on a DAAD grant to Berlin, but I wanted to live in the country to write another novel and have Ethan in an English-speaking school. An eerily precise dream and pure serendipity (driving around Totnes with my friend Anne Twitty) found us an old stone cottage [134] in a valley among rolling green hills where we became part of Janet and Robert Boyce's extended family. Every afternoon I hiked for hours through the woods and fields of local farmers who were fine with trespassers so long as you closed gates and your dog didn't chase stock. (The one time Gnasher broke that rule was to save me from being run down by a gang of playful young steers; he fended them off until I could reach the hedgerow.) Ethan attended King Edward VI, the local comprehensive school, where he immediately made friends, as he is wont to do. We had an idyllic year with occasional trips to London. I began lifelong friendships with Susan Hiller and David Coxhead, Margaret Harrison and Conrad Atkinson, Alexis Hunter, Rasheed Araeen, Peter and Cathy Kiddle, and my wonderful landlords, Robert and Janet Boyce, with their three boys.

Every week or so Gnasher and I drove up to the looming Dartmoor, in a car that had to be pushed downhill to start. (I rented it from a man named Crook who shared my birthday.) There I got my first taste of the megalithic monuments

133

134

— stone lines, stone circles, and standing stones rising from the perennial mists.[135] The dog often found what I was looking for first. I'd trudge up to a stone circle to find him lying smugly in its center.[136] At Christmas, Ethan went home to his dad for vacation and Charles and I explored the megaliths of Brittany. In late (and rainy) spring, we three rented a small RV, and toured the megalithic sites in Scotland and its isles. It didn't take long for me to become obsessed with these amazing sites and to begin writing about their connections to contemporary minimal sculpture, feminism, and land art.

The novel I wrote in England was called *The First Stone*. It followed three generations of women and how politics affected their lives. I had a wonderful time writing, but it needed a lot of work to be publishable. (My friend the novelist Esther Broner was kind about it, but said the dialogue was awful.) After returning to New York, I was losing interest in it. I wandered instead into the book that became *Overlay*: *Contemporary Art and the Art of Prehistory,*[137] which better embodied my Devon year. No one was particularly interested in it until I sat next to a quiet man at a dinner party, who turned out to be the legendary publisher Andre Schiffrin, then of Pantheon and later the founder of The New Press. He came to the loft to see the slides and, on the way out the door, said he'd publish it — a far bigger break than I realized at the time. This was the book that opened up vistas beyond the art world and set my path for the next forty years.

I have much in common with Michelle Stuart,[138] an early

138

139

140

Heretic (member of the Heresies Collective) and longtime friend, who was a major source for *Overlay*. We share a fascination with historic photographs, earth, history, family, nature, archaeology, and the distant past. She combined her photos of the iconic Avebury megaliths with her signature use of lower panels rubbed with soil from the site. Finally, in her eighties, she was recognized as the important artist she has been for decades — the fate of so many women artists of my generation.

◆

As a child, Ethan was photographed for the Honeycomb box [139] and liked to hang around in the cereal aisle when I was shopping at the Grand Union. He didn't spend much energy on schoolwork at Elizabeth Irwin High, though he spoke at graduation, deciding what to say a couple of hours before it took place, making his teachers very nervous. (That same night I was speaking at an anti-nuke rally, also

141

142

preparing at the very last minute.) Ethan's childhood TV commercial gig led to a brief acting career in his teens.[140] As a member of the Screen Actors Guild, he made more money from these occasional gigs than I did from full-time art writing.[141] Somewhat to our surprise, though he always aced interviews, he was admitted to Carnegie Mellon's prestigious acting program. After a year of trying to juggle liberal arts with a full-time conservatory schedule, he decided that unlike his fellow aspiring thespians, he "didn't want to be somebody else." He came back home, enrolling in the New School's Jazz and Contemporary Music program, although he had never studied music and played only his own compositions on the old upright piano I'd inherited from a former lover. They told him he was good but had to start from scratch. He lasted a year or so and then used his commercial money to start The Box, a recording studio on lower Broadway for his Hip Hop peers, until the funds ran out.[142] In the early 1980s he and some friends from City as School — Blaise DuPuy, Ramon Diaz, and Gerardo Maza — formed a band called Nisa, which had a brief but productive life. For some twenty years Ethan worked in the music business with his own Are & Be Productions, Joints That'll Move Ya, and Speak of the Devil Entertainment, most famously engineering for the Wu Tang Clan; ODB used some of his beats — names I try to drop for street creds when I'm speaking at colleges.

◆

143

144

In 1979, after returning from England deeply impressed by activist and political art in London, I curated *Some British Art from the Left* at Artists' Space. On the announcement card I scheduled a meeting at Printed Matter to initiate an archive of international socially engaged art. I said firmly this was not about starting another activist artists' group. Of course, by the end of the meeting that's just what happened, along with the planned archive, which ended up at MoMA because one of the founders was Clive Phillpot, MoMA's librarian for years, and a significant scholar and advocate for artists' books. He suggested the name for the group we were "launching": PAD/D (Political Art Documentation/Distribution, last word added a year later).

145

One of the first responders to the PAD/D meeting calls was painter and conceptual artist Jerry Kearns,[143] a White activist with the Black United Front. We became working partners for writing, performance, curating, and rabble-rousing in the early 1980s.[144] PAD/D brought together old and younger art activists and a new Left art community was formed. Jerry and I organized exhibitions, demonstrations, Second Sunday talks and performances at Franklin Furnace.[145] PAD/D published *Upfront*,[146] an occasional magazine, as well as *Red Letter Days*, a monthly broadside

146

147

148

149

listing progressive events and shows in the city. One of the Young Turks who saw Jerry and me as "commissars" was artist Gregory Sholette, another PAD/D co-founder, now a valued friend and colleague, renowned author and international leader in progressive theory and social practice.[147] We worked closely with other activist artists in Group Material, Colab, Fashion Moda in the South Bronx, and NAPNOC — Neighborhood Arts Programs National Organizing Committee, thankfully renamed the Alliance for Cultural Democracy (too many knock-knock jokes). Its founders were my friends and mentors Arlene Goldbard and Don Adams. (Arlene, writer, artist, and brilliant "policy wonk," now lives five minutes away from me in New Mexico with her second husband, sculptor Rick Yoshimoto, and has returned to painting.)

In 1982, PAD/D and the Alliance for Cultural Democracy organized the February 26th Movement, a one-day conference at the union headquarters of District 1199, where, thanks to director Moe Foner's Bread and Roses programs, Kearns and I curated several exhibitions, among them Haacke's slumlord project for which his Guggenheim show was canceled, and *Who's Laffin' Now?* with comic-oriented art;[148] Keith Haring painted a frieze around the room and Mike Glier made a huge title mural of a vampire Reagan. Glier and I also curated *Vigilance*, an artist's book show at Franklin Furnace.[149]

In 1982, with Candace Hill-Montgomery, I co-curated *Working Women / Working Artists / Working Together*,[150] at

1199. All these shows offered us a diverse non-art audience and taught us some lessons about working beyond the artworld's white walls. I loved the certainty of being a lefty activist. I believed we were right and had trouble

150

understanding why everybody didn't agree with us and why some of those who did still wouldn't join us, thanks to the complexities and nuances of everyone's lives.[151]

151

◆

In January 1980, Charles and I, Sol LeWitt and his wife Carol Androcchio, with a small group of other art types — some of us proud Socialists — went to China on a guided tour, just as the Gang of Four was deposed and China was edging into communist capitalism. In Beijing and elsewhere it was very cold. We were always given warm, covered cups of tea to clutch while we were regaled with communist triumphs at factories and cultural centers. On a visit to a Shanghai Cultural Center filled with enthusiastic artists in all mediums, a Chinese artist rapidly whipped out a beautiful scroll of a waterfall for us.[152] None of our group could reciprocate, so I suggested we try an Exquisite Corpse group drawing in return. Not pretty, it was politely received with a certain bafflement at our ineptitude.

152

◆

I had first heard the term ecology from Iain Baxter in the 1960s, and somewhere early on I wrote that I would always

153

154

155

be more moved by nature than by art. My commitment to the environment was heightened by the time I was hiking every day in Devon, plus exposure to New York artists like Christy Rupp,[153] who was an eco-artist before the term was widespread, painting urban wildlife (rats) on walls in Lower Manhattan. (Decades later we were amazed to run into each other hiking in Oak Creek Canyon in Arizona.) Since then eco art has become a focus. In 2007 I curated *Weather Report: Art and Climate Change*[154] at the Boulder Museum of Contemporary Art — a crucial learning experience, sparked by tireless eco-advocate Marda Kirn.

◆

I met Ana Mendieta[155] in the late 1970s while lecturing at the University of Iowa. At a party after my talk, she cornered me and told me her whole history as a child refugee from revolutionary Cuba with her older sister Raquel, eerily reminiscent of Eva Hesse's and her sister Helen's lonely journey from Nazi Germany. Ana soon moved to New York and became a good friend. Later, when she was leaving for a fellowship in Rome, she brought me a pot inscribed with a hammer and sickle to keep for her, saying it was her "revolutionary soul." While she was gone, it was on my desk. Once it suddenly emitted a puff of smoke. She had worked with gunpowder, and I asked her if that was where she'd kept it? She smiled mysteriously and said no, that was a message from elsewhere. (Ana was into Santeria, Candomblé, Abakua, and other Afro-Latinx religions.)

Ana married Carl Andre in 1985, and only a few months

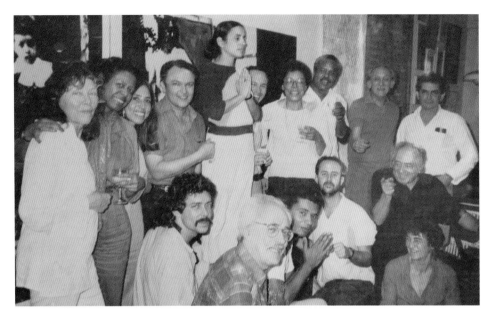

later she died in what sounded like a drunken argument, during which she fell or was pushed from the window of their thirty-third-floor apartment. Carl attended the memorial at an uptown center for Latin American art, which was awkward. I was in Boulder during his trial and thankfully did not have to testify. They had both been friends of mine and nobody knew exactly what had happened. I did tell the DA in a phone interview that Ana was decidedly not suicidal, though that was the court's final decision. This became a divisive issue in our circles. Andre was acquitted, but the case remains a thorn in feminist flesh, and Mendieta is often remembered at demonstrations to this day. Her art has become much in demand ever since, but she is not around to enjoy that.

In 1981 I joined a group of artists[156] (among them Mel Edwards, Jayne Cortez, Herb Perr, Suzanne Lacy, Dan Higgins, and Martha Rosler) to travel to Cuba with Mendieta

157

158

as our tour leader. It was an eye-opening visit, thanks in part to art critic Gerardo Mosquera. We hung out with the amazing young generation of artists who have since become visible in the global art world. I returned in 1986 with Baranik, Stevens, and others to bring a donation of artworks — a gift from U.S. artists to the Cuban people — and to see the second Habana Bienal.

◆

In the late 1970s, I met Natasha Mayers [157] at an art show in a church in Head Tide, Maine, and later sent her a note about her drawings shown in a shop in Bath. She turned out to be the primo activist artist in the state — modest, indefatigable, and a good painter to boot. Every summer she is the first person I rush to see, and we have ranted and skinny dipped at Skowhegan, Georgetown, and in the Sheepscot River that runs through the woods near her funky house in North Whitefield, where for years she and cohorts have organized humorous political floats and actions for the July 4th parade. With the Artists Rapid Response Team (ARRT) she makes banners and yard signs for endless different Maine organizations. In 2022 we spent an illuminating couple of nights at the Smithereen Farm, home of the Greenhorns in the rapidly changing downeast town of Pembroke, Maine. A 2021 film about Natasha directed by Anita Clearfield and Geoffrey Leighton — *Natasha Mayers: An Unstill-Life* — is a prize-winning film festival regular. Ominous cutouts by her son Noah Apple hang in my bathroom. [158]

[82]

159

Around 1980, the American Indian Community House briefly had a gallery in the iconic West Broadway building that housed prestigious dealers like Castelli and Sonnabend.[159] When I wandered in, the artist curators, Peter Jemison (Seneca) and a young Jolene Rickard (Tuscarora), immediately saw that I knew nothing about contemporary Native art and they took on my education. Soon afterwards I was asked

159A

160

161

by Jaune Quick to See Smith (Salish Kootenai Nation) and Harmony Hammond, co-curators of the exhibition *Women of Sweetgrass Cedar and Sage* (1985), to write a text for the catalogue. On a trip to New Mexico, I spent time with Jaune and Hopi artist Ramona Sakiestewa, who continued my education, though at first I got my essay all wrong and had to restart from scratch. From then on, I was introduced to other Native artists who are still being belatedly recognized by the artworld. Indigenous art — hard to ignore in New Mexico — remains a focus of mine, and I continue learning.

A feathered peyote wand from the Native American Church and an Amazonian feather headdress [159] are beautiful and evocative, but I worry a bit about these gifts from writer and curator MaLin Wilson and jack-of-all-housing-trades Greg Powell, with whom my partner and I took a delightful trip many years ago to Casas Grandes and the Pueblo site of Paquime in Mexico. I stare at the headdress, trying to picture its original use and habitat, and wondering if it's sacrilege to own it.

In 1992, our community of activist artists in New York mounted a campaign against Columbus Day (now Indigenous People's Day in many states), which included a handbook — *How to '92* — on activist art strategies,[160] questioning conventional histories and precursing the current wave of downed monuments. My book *Partial Recall: Photographs of Native North Americans*,[161] came out that year, with essays by Native artists, each writing about a single photo of their choice. It was sparked by a postcard sent me by Canadian Plains Cree artist/curator and longtime friend Gerald McMaster. Although the book has received a warm reception in Indian Country, my publisher was discouraged by the sales and said No More Indians.

[84]

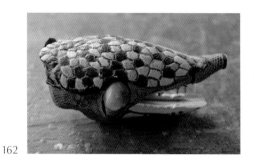

162

One of the contributors was Jimmie Durham,[162] whose painted armadillo skull in my house is, alas, the worse for wear these days, having lost a shell eye and both ears. The artist wrote a poem connecting it to Tarascan guitars, Indian history, and Sequoia, the Native scholar who invented the Cherokee alphabet and later disappeared in Mexico. "I painted the armadillo's skull bright turquoise and orange, blue and red, black, green, like tiles and Aztec flowers. / Where his old eyes had been I put an agate / and a seashell, for seeing in all directions."

As editor of *Art and Artists* newspaper (1982–85) and director of the Foundation of the Community of Artists in New York, Jimmie was an activist friend before his work became famous and his debated status as an unenrolled Cherokee became a cause celèbre. In February 1993, I wrote a cover story in *Art in America* on his work ("Jimmie Durham: Postmodern Savage"), immediately after which he wrote a letter to the editor saying, in true trickster fashion, that he was neither Cherokee nor Native American. Since then, he has been accused of being an Indian Wannabe, since his family's detour from the Trail of Tears into Arkansas, Texas, Louisiana, and Oklahoma resulted in a lack of official enrollment in the Cherokee Nation. Despite his attempts to abscond from the U.S. and the art world, he became perhaps the internationally best-known American indigenous artist, and after trying out Mexico, Ireland, and Europe, he and his longtime partner, artist Maria Thereza Alves, settled in Berlin, still productive, still controversial, despite ill health. He died in 2021.

◆

For four years, beginning in 1981, I was hired to write a monthly column in *The Village Voice* about art and politics. One column was on Carnival Knowledge's feminist performance artists collaborating with sex workers. I had a field day with erotic puns

163

164

165

and my rather prudish father wrote me a very serious letter warning me that no one would ever ask me to lecture or write again.[163] Luckily he was wrong. In 1985, the same year the Guerrilla Girls burst onto the scene, I was fired by a new editor at the *Voice* for doing exactly what I was hired to do.[164] Activist friends gave me a farewell picnic at the Battery and a foam rubber Statue of Liberty crown. For a while, I took my column to *In These Times* and *Z Magazine* but was laid off by them as well — too much about art, which although respected as a sometime ally by the Left, was not considered real tough politics. At one demo in D.C., events were running late, and the march's leaders suggested cutting the art and poetry on which we had worked for weeks. We refused to be eliminated, but it was a sad moment.[165] I wrote about art being perceived as either above it all (off in an elite cloud) or below it all (bourgeois frippery not worth considering). My next book, *Get the Message? A Decade of Art for Social Change* covered this era.[166]

166

◆

Ethan was and still is great company, in Maine, in Spain, in England, in the Northwest where we spent a couple of weeks of his childhood driving around looking at art across Washington and Oregon for an exhibition I juried. I probably treated him more as a companion than a mother should. He put up with my various lovers. I told him the men would

[86]

169

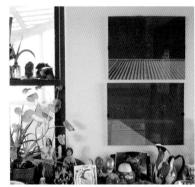

167

come and go but he'd always be first in my affections. Now and then we still engage in a battle of wills.

As a teenager, Ethan swore he would never enter "the family business" — contemporary art. In his early forties he succumbed to the fate he had been studiously avoiding for more than twenty years of acting and music production, finally becoming a visual artist like his father, his stepmother,

170

and his two half brothers. Happily, I really admire his formalist work, based on ironic dimensionalism and inventive confusions of photography, painting and sculpture... no politics. He's his father's son. Two large photos of the tin roof of my annex [167] taken from different angles against bluer than New Mexico's blue skies, are early works presaging his *Convergences* — an ongoing Instagram photo series (@-titan_of_leisure) in which the geometric intersections of buildings transform three dimensions into two.[168] Other works burst into three dimensions again by subtly irregular mounts. A small triptych looks at first glance like a geometric painting in black, white, and muted brown.[169] In fact, it is a more complex affair — photographs of his floor sculp-

168

171

172

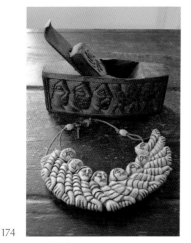

174

175

ture *Performer,* which was exhibited with it. And one of my favorites is a pen and ink drawing labeled "I made you this portrait of Roland Barthes because I wanted to give you a holiday gift, but I didn't want to shop." [170]

Max Becher, Ethan's best friend in high school and beyond, and his wife Andrea Robbins have collaborated for decades. They gave me a memorable view of Havana in a blackout (during Cuba's "special period") [171] and a smaller piece when they were exploring "German Indians." I owned two early photographs by Max's parents, Hilla and Bernd, given to me by Sol in the mid 1960s, now in the New Mexico Museum of Art.

◆

In the early 1980s, the arrival in New York of Salvadoran exile and activist filmmaker Daniel Flores y Ascencio, representing the Institute of Arts and Letters of El Salvador in Exile (INALSE), triggered growing interest in the wars in

173

and on Central America, taking place with the blessing and often backing of the U.S. government.[172] Doug Ashford, a member of Group Material, had already organized an exhibition on the subject and he and I and Flores, with a broad spectrum of other artworkers, formed *Artists Call Against US Intervention in Central America,* which became a nationwide (plus Canada) campaign to counter Reagan's illegal support for the Contras, who were undermining a then-progressive Nicaraguan revolution. Eleven hundred artists participated

in some thirty exhibitions in New York alone, as well as films, lectures, poetry readings, performances, and public art, and many more across the country. The poster was designed by Claes Oldenburg and the button by Peter Gourfain,[173] a Minimalist deserter whose Romanesque-like works in clay, wood, and print are uniquely political. When he gave me a lovely clay necklace of Romanesque heads, I hugged him and broke it.[174] Also from Peter, a carved wooden plane and any number of woodcuts on recycled paper.

In July 1983, a bunch of us lefties, or "Sandalistas,"[175] (including the great poet Adrienne Rich, photographer/lawyer Jack Levine, and Martin Lee, co-founder of FAIR) went to Nicaragua, an eye-opening trip that took us to a conference in Managua and into the war zone on a decrepit bus. We met with Ernesto Cardenale, Sergio Ramirez, Omar Cabezas, Julio Cortazar, and First Lady Rosario Murillo, among others.[176] Ramirez told us that peasants in El Salvador were as poor and oppressed as those in Nicaragua, but there were limitations on mutual support because if the U.S. could prove arms were being sent, they'd have the pretext they were looking for to invade Nicaragua.[178]

In the late summer of 1984, I went to Nicaragua for a second time, and then alone to San Salvador, where I saw the deserted and graffitied National University, once a base for the opposition, and its skeletal remains in a courthouse room, a card table representing each faculty. A kind driver hired by the university took me around the countryside, dangerous for him and depressing for me, as I had trouble

176

177

178

179

180

understanding his local Spanish, too unlike the Mexican, Cuban, and Nicaraguan varieties. I stayed at a humble hotel and saw only one dead body in the street. During that week, I went to an art gallery opening where I was told that the apparently neutral art on view harbored hermetic political messages. (Since then, I have seen a reproduction of an overtly outraged work by Carlos Cañas that I'm told was in that show; not sure how I missed it.) As I awaited my departing flight there was a seismic *temblor* that shook the airport, a fitting climax to a strange visit.

On my return from one of these trips, then-boyfriend, painter Noah Jemison[177] (father of the great Black sci-fi novelist N.K. Jemisin) picked me up at the airport in a car borrowed from a woman friend, triggering a series of disturbing and sexually suggestive phone messages to all of us, pretty surely from CIA connections; others on the trip had similar experiences. *Artists Call*'s year of local and national organizing culminated in a series of events in early 1984, kicked off by the Verdadera Avenida de las Americas, a block of West Broadway between Houston and Prince transformed by murals and performances.[179]

Although I was all agog at an invitation to hike through jungle and mountains in El Salvador to reach the FMLN liberated zone and write about it, the daring and committed photographer Susan Meiselas warned me that the fear factor was huge; I shouldn't go unless I thought I could really make a difference (as she had). Finally, in a rare moment of maturity, I realized that neither my fitness nor my Span-

[90]

ish language skills were up to the job, and that an article in the *Village Voice* would not change the world. I declined, although when I told my son I might embark on a dangerous journey he said, "Go for it, Mom; it's just the kind of thing you always wanted to do!"

After one Artist's Call meeting, we went out for drinks, and I recounted a dream I'd had of dying — a pleasant swooning sensation. The next morning the unique writer/artist/activist Julie Ault, whose mother was a kitchen-table psychic in Maine, brought me a crystal and told me I had some death coming in the family; she wasn't going to say anything, but my dream had convinced her I'd be okay. Just before Christmas 1984, my father died suddenly of his second heart attack, at age 79. Life changed for eight years as my mother,[181] first at home, then in a New Haven retirement home and summers with me in Maine, struggled with health issues and a lonely new life. I in turn struggled with trying to make that better, with some success but little patience. Menopause didn't help. One of Peg's great pleasures was wildflowers. Like her mother before her, she was an enthusiastic amateur botanist. In 1981, we published her *Wildflowers of Georgetown Island*,[180] the covers designed by Ellen Lanyon, an early eco artist and feminist pal who lived in the loft beneath ours on Prince St.[180A]

180A

181

182

◆

I was brought back to New Mexico by feminists. In January 1985, after being sequestered with my mother since my father's death, I had a gig in Santa Fe. I first saw the village

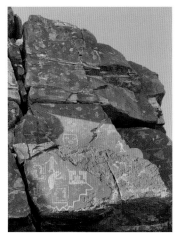

183

184

186

of Galisteo in the middle of the night. Judy Chicago,[182] her photographer husband Donald Woodman (former amanuensis of Agnes Martin, who also lived in the village), with Galisteo residents Romona Scholder and Patrick Mehaffey, led me up the northern *creston*, or hogback — one of the two volcanic dikes rich in petroglyphs that frame the village of Galisteo — to view Halley's Comet. [183] Someone said we were among petroglyphs by the Tano people who built eight major pueblos in the Galisteo Basin in the thirteenth to fifteenth centuries. "You'd like this place," they said.

Three years later, I was hiking the southern *creston* with Colorado friends. Harmony Hammond (painter, LGBTQ

 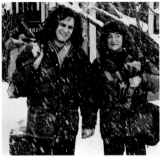 

187, 188 185

heroine, author of the path-breaking book *Lesbian Art in America*, and fellow Heretic) [184] had suggested that I stop in Galisteo, in daylight this time, to see the property she was thinking about buying — an old stone wool warehouse (*la lanera*). I walked alone across the wooden bridge to the other side of the Rio Galisteo, feeling like an intruder. [185] Within a few years I would live there.

189

◆

In 1986 I accepted a "distinguished visiting professorship" for one semester at the University of Colorado at Boulder, where in 1973, accompanied by Charles and Ethan, [187, 188] I had spent a couple of weeks as visiting artist. I was mistakenly called Dr. Lippard. I loved being in a then-funky cabin in the Chautauqua, on the edge of the Flatirons and glorious hiking trails, so in 1987 I came back as an adjunct for eight years, teaching one seminar one semester a year, which gave me time to write and allowed me to keep my non-academic status. New York art activism was running out of steam, but the People's Republic of Boulder was

190

not... yet. Whenever there was a crisis, like Desert Storm, we could alert hundreds of students, a relief after years of prying artists out of their studios and into the streets of New York. I was immediately drawn into CISPES with local activists, including artist Hank Brusselback, who was the projectionist for my first year at CU. Over the years, we formed activist street performance groups: Outside Agitators,[189] The Pink Medicine Show, and Damage Control[190] ("five women over 40": Jennifer Heath, Caroline Hinkley,[186] Annie Hockmeyer, Kristine Smock, and I, protesting the Gulf War). At some demonstrations we were seven-foot-tall Wailing Women, modeled on Suzanne Lacy's and Leslie Labowitz's 1977 *In Mourning and in Rage* performance on violence against women in Los Angeles. With Caroline, I co-curated *2 Much* — an exhibition in the Student Union to protest Colorado's homophobic Amendment 2.

One of the graduate students in my CU seminar was Melanie Yazzie (Diné),[191] who now heads the printmaking department at the university. She became a dear friend and vies with Kathy Vargas as one of the most generous souls I know. Over some thirty years of friendship, Yazzie has given me paintings and drawings, earrings straight out of her ears when we ran into each other on the Santa Fe Plaza during Indian Market, a Navajo pictorial weaving, a china baby doll, a chunk of obsidian (or coal?) a commodity flour sack, and even her dance moccasins. One weekend when Melanie was teaching at the Institute of American Indian Arts in Santa Fe and staying at my new Galisteo house, I came down from Boulder to find my one room crowded with way-over-life-sized ceramic dogs. I wish I had taken a photo. Melanie's second wedding was at Canyon de Chelly's Spider Rock overlook. Some tourists joined us, having no idea what was going on, and Melanie typically invited them to the reception at a Chinle diner.

◆

In the 1980s, I became (belatedly) obsessed with what was then called multiculturalism.[192] In those days the term meant everyone across the ethnic board. Today only POC qualify. I participated in panels and conferences, met a lot of amazing people,

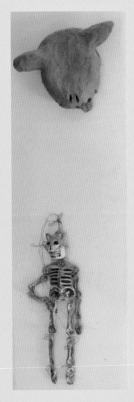

¡Recoge tu Destino, purincando en esta luz
que se ha tornado petrea. Ni sol, ni
lluvia, ni traición, ni nada, podrá borrar
lo que se ha escrito en piedra!

192

192A

and learned a hell of a lot, which still doesn't keep me from putting my foot in my mouth around race issues in these touchy times. My Boulder seminars were cross-listed with Women's Studies and Chicano Studies, and for several years I organized an annual symposium called *Mixing It Up*, inviting four women artists of color (one African American, one Asian American, one Latina, one Native American each year).

Having checked in with several friends of color, I was writing *Mixed Blessings: New Art in a Multicultural America*, published in 1990.[192A] The cover is a painting by Kay Miller, a Boulder friend of Comanche and Metis descent. When the book came out, I got some expected flack, but it was generally well received. Focused as it was on the now-out-of-fashion Identity Politics, it is, to my surprise, still being used in university classes. In 2020, while writing a dialogical essay on Whiteness with Peggy Diggs, we discovered that once the mea culpas are over, it is much harder for White women to talk about Whiteness than about Blackness and Brownness.

Two Latinx activist artists from opposite coasts were particularly significant for these endeavors. Yolanda Lopez was a Chicana feminist and La Raza leader in San Francisco whom I got to know through early multicultural activities when *gabachos* were still invited. Juan Sanchez is an Afro-Nuyorican Independentista, activist and friend. His print, with its reference to Taino rock art, is a bridge between my lives.

Another Chicana stalwart is photographer Kathy Vargas, whose skeletal work print I have put in an ornamental New Mexico tin frame, hanging from it elaborate necklaces from Nepal she has given me over the years; I only wear them on very special occasions, but they are too beautiful not to treat as art. We met in 1986 when I got bored at a sculpture symposium in San Antonio and a friend of hers suggested that

Margaret Isham Cross Lippard:
A Good Life

(October 15, 1907 - June 5, 1992)

193

194

I get Kathy to show me the city's Chicano murals. She was watching *Jaws* and tore herself away. A dedicated shopper, she is also responsible for all kinds of stuff around my house, including her own innovative photographs (which went to the New Mexico Museum of Art), some gorgeous textiles, the beaded African wand over the fireplace, a Haitian voodoo flag, and clothes much nicer than I ever get for myself.

In May 1992, Kathy and I were planning to visit the ancient Mayan site of Tikal, but at the last minute there was fighting in the streets of Guatemala City so we ended up in Oaxaca and Monte Alban instead. In a museum there we saw reliefs created centuries ago — perfect portraits of Kathy's profile. (She has Zapotec and Huichol ancestry.) On the way home I stopped in Mexico City, and late one night I was notified that my mother had had a stroke. I finally got a flight out the next morning; it cruised to the end of the runway and stopped dead with mechanical problems. Eventually I made it to New Haven in the wee hours, clutching a rattling rainstick for Ethan. When my father died in 1984, exactly the same thing had happened. The train from New York to New Haven was canceled just before departure. Curious karma.

Peg Lippard died of a stroke in June 1992 at the age of 84, and in July we held a memorial in the front yard of the Kennebec Point house, attended by people who had known her all her life.[193] For her friends elsewhere I made a little booklet about her. She always said she'd had a good

[98]

195

life — except for her high school years, and until my father's death.

◆

The Boulder Center for Peace and Justice was the hub of local activism, and, around 1987, a few of us went down to Tierra Amarilla, New Mexico, to support a group of Hispanos who were fighting off developers on the historic land grant that had ignited the famous earlier struggle led by Reyes Tijerina. We arrived to find the *matanza* (slaughter) of a sheep underway, my introduction to rural New Mexico.[194] We met the *consejo*, community elders advising the more militant La Raza members. On another trip, Boulder activist Chris Takagi and I wrote an article in the *New York Guardian* about the camp. I interviewed the elder women in the *consejo,* but, when I took the tape back to New York to translate with help from Latina friends, no one could understand the New Mexican Spanish, and it was never published.

In Boulder I also fell in with some hiking and rafting friends and was introduced to the Ancestral Pueblo sites and rock art of the southwest, which set me off on a new trajectory about indigenous history and place. My first trip was with photographers to Canyonlands, where after a strenuous day we danced drunkenly to car radios. That night it rained buckets. I couldn't deal with everyone crowded into one tent, so I plunked my sleeping bag near the edge of an arroyo and was almost engulfed by a flash flood. We crept along precariously crumbling cliff paths to ruins. Another woman and I swam in the Green River and were almost swept away. In retrospect it was a dangerous as well as exhilarating week. I was hooked. Extensive hiking trips to the Four Corners area, with its ancient ruins and petroglyphs and pictographs, cemented my obsession, which has not yet dissipated. One memorable trip was with Boulder

friends on two rowing rafts down the San Juan River, where we camped on its banks and hiked inland to archaeological sites. I thought I could use my Maine boating expertise, but rowing a rubber raft facing the "wrong way" was a challenge. A pure white mule who followed us at Chinle Wash became the totem for an eventually discarded novel called *Upriver*.[195]

◆

In the late 1980s I drove solo to Dinosaur National Park to see more rock art, a bit worried about my "radical" bumper stickers in conservative Utah![196] Rejecting the crowded campground, one night I deployed my sleeping bag illegally on the grounds of a pioneer woman's ranch in the park. Around midnight, with the moon filtering through tall pines above, a coyote ran right by me. A magical moment. Driving back through western Colorado, the title of a germinating book came to me: *The Lure of the Local*.

In the late 1980s, I was teaching a seminar focused on place and the local at CU when I accidentally "discovered" that there was a field called Cultural Geography. Not being an academic, I had never heard of it. After sitting in on a class taught by Don Mitchell, it led me in a more informed direction that I was already contemplating from ignorance, and one that has guided my work over the last three decades. Caroline Hinkley did me the enormous favor of introducing me to the remarkable work of John Brinckerhoff (J.B.) Jackson, an influence ever since on my writing about the cultural landscapes around us. When I moved to New

196

Mexico, I met Jackson's prime heir, cultural geographer Chris Wilson, who continued my education. Another component was William deBuys's *Enchantment and Exploitation*, an enduring book on northern New Mexico. The result was *The Lure of the Local: Senses of Place in a Multicentered Society*,[197] followed by a chapter that got loose and went off on its own to be published later as *On the Beaten Track: Tourism, Art and Place*. The ways in which the land incorporates and unearths both public and individual memories is the reason senses of place is plural.

◆

After my mother died, I took up with Peter Woodruff, eleven years younger than me, whom I had known since he was a baby on Kennebec Point.[198] A ship mechanic at the Bath Iron Works, he was also a talented watercolorist, photographer, diver, and amateur archaeologist. For seven summers we tramped the woods and boated local inlets looking for historical evidence of Native and settler lives. Stage Island, just across the narrow gut from his family's home on Kennebec Point, is an amazing indigenous and early colonial site and Peter's sharp eye for artifacts washed up on the beach or surfacing in the woods was a boon to local archaeologists. When he visited me in New Mexico, he continued to find things I had never noticed, including an ancient stash on the hill above my house. One is a beautiful chert piece described by a friend, the late brilliant Tewa scholar Rina Swentzell, as "some woman's favorite scraper" centuries ago. The battered found metal plate [199]

197

198

199

200

201

203

202

full of artifacts also includes a handsome arrowhead Peter and I found washing out of seaweed on a Maine island. Still in the Maine house is an ancient Morehead plummet (fishing weight) found, again, as it was about to wash into the sea around the lighthouse on Seguin Island. Peter died in 2021 and the family sent his ashes into the gut, toward the island and into the sea he loved.[200]

◆

When Harmony moved to Galisteo in 1989, I began to stay with her on my New Mexico forays.[201] After my mother's death, I had some money for the first time in my life. When a strip of overgrazed pasture across the creek was divided into lots, I didn't think twice. I bought some five acres next to the then-quieter rural highway, with an unbroken view across rangeland to the Ortiz Mountains. Bart Kaltenbach and Ren Greene, who had built Harmony's Guggenheim-funded studio and Bruce Nauman's and Susan Rothenberg's compound up the road next to the remains of the Galisteo

[102]

Pueblo, built me a little house, 16′ × 24′ (since expanded bit by bit, whenever I could afford it), and I moved to New Mexico. They don't call it the Land of Entrapment for nothing. I was always saying that I moved to New Mexico to get away from art, which annoyed my artist friends. [202] Actually, it was the art world I was finally escaping. Art still means a lot to me. It's my base but no longer my obsession. I wanted to broaden my life, ironically by narrowing it down to a tiny community. [203, 204]

204

I found out later that my little house in Galisteo [205] was locally called "the shack by the creek" or the "Smurf House." Off the grid by necessity, I plugged it into my car battery for a year or so and lit the house with candles and oil lamps. I was told that the dayglo plug sticking out from under my car's hood was a badge of honor; in New Mexico, it means you're rural. Even so, I was advised to hide my solar panels in the arroyo when the inspectors came. Peter installed a single panel outside and a golf cart battery under my couch, and eventually I got a more elaborate renewable setup. It's worked well, partly because I don't need a dishwasher, TV, washer/dryer, or microwave. When I tell friends back east that I'm off the grid, they tend to agree that I always have been, with no idea that it is a physical fact.

205

When I built my little home in Galisteo I was alone on a strip of former farmland now occupied by three other houses. I was asked if I had a gun and a dog. No, but like a proper *bruja* I had my little black cat China (named by a former lover's child because she was black and shiny).[206]

206

[103]

208

207, 209

210

211

She came to Maine with me for years, bringing gifts of rodent bile sacks onto the rugs and hiding in the beach grass when I was out sailing, emerging from the tall grasses to greet me when I landed, until my son's and daughter in law's cats Freedom and Lucy — bigger, younger — made life too miserable for her. After that she had interesting sitters in Galisteo, the brilliant writer/activist and longtime hiking pal Rebecca Solnit being one of them.[207] Another was Patsy Norvell, a feminist artist friend known for her public art and early student interviews with conceptual artists. She stayed with China for the last two months of the kitty's life. China died at age nineteen while I was far away. As she was failing, Patsy carried her around the yard and down in the creek to all her favorite hiding places before she was put down and stored in the freezer so I could tearfully bury her in the back yard on return. I have always connected Patsy's piece, made in Galisteo,[208] with China's death: a fresh green yucca pod was placed next to a painting of itself. The painting of

course is static but change has taken place: the real yucca has aged slowly and is now a brown shell, a memento mori. Patsy herself died too soon afterwards, in 2013, of acute myeloid leukemia, a disease that also claimed Nancy Holt the next year. [209, 210]

212

Since the 1990s, Harmony Hammond, May Stevens, Nancy Holt (who had moved to Galisteo around 1994), and I called ourselves the Galisteo Gals. [212] Two of them are now gone, but the Gals have been augmented by newer neighbors. When her lovely house in Fourmile Canyon near Boulder burned to the ground in September 2010, photographer Caroline Hinkley finally moved to Galisteo. She and her now-wife Angie Beauchamp — both then film theorists at the University of New Mexico — joined the Galisteo Gals, along with woodworker Laura Yeats [211] and activist artist Peggy Diggs, best known for her milk cartons alerting users to domestic violence. (Jim Faris and Peggy's husband Ed Epping, [213] who makes intricate works about social justice and incarceration, are honorary Gals, as are canine members Gordon Cole, Zeke, Lucy, Thunder the Wonder Dog, Yazzie, my late adored Chino, and now Tanita la Bonita.)

213

◆

When I moved to New Mexico for good in 1993 I handed the "family mansion" — the loft on Prince Street — over to Ethan, who still lives there. Given my new domain, major downsizing was necessary. I donated a huge number of beloved artworks to the Museum of Fine Arts (now the New Mexico Museum of Art) in Santa Fe. In 1998 the museum

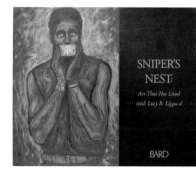

214

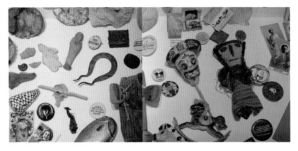
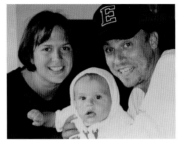

215 216

mounted an exhibition of my stuff instigated by Neery Melkonian at Bard College. It was titled *Snipers Nest: Art That Has Lived with Lucy R. Lippard;* [214, 215] because it's mostly gifts from artist friends, I rejected the notion that it was my "collection." The show occupied the museum's biggest ground floor space, three rooms worth, which I got to install myself. The first room was the bright yellow of my new home's interior living space, offering a dense display of personal odds and ends, political posters, and some multicultural art. The second, larger room was a paler yellow and included mostly women's and feminist art. The third room was white and focused on Minimalism and Conceptual art. When Judy Chicago's print, *Red Flag* (a tampax being removed from a vagina) was shown, the museum's foundation posted a warning to visitors. I added a comment: "Think for Yourself." Because I no longer live with those works, I haven't included them in this book which is kind of unfair to their makers, most of them close friends. But I had to draw the line somewhere. This was not meant to be a tome.

◆

In 1995, Ethan married Kyla Adams, a reading specialist in New York public elementary schools with a Bank Street degree. [216] (Later she published Home Grown Books, delightful little volumes "for first readers," all designed by artists, among them Kathy Bradford, Wangechi Mutu, and Max Becher/Andrea Robbins.) At the end of August, I became a grandmother. Tired of waiting for Samuel Justice Ryman to arrive, I flew

[106]

down from Maine to New York on Labor Day weekend, and by the time I got to the hospital he had emerged. A big moment. The Ryman family, augmented again in 2003 by the birth of Calvin Tracy Ryman, came for years to New Mexico on spring breaks.[217] We toured the state visiting far-flung friends and reveling in the infinite variety of cultures and landscapes.[218] One Easter we spent the holiday with Melanie Yazzie and a cousin of hers in Tsaile on the Navajo Nation. We took turns carrying heavy Sammy down into the Canyon de Chelly, while Melanie whisked him effortlessly up the cliff on the return. She attributes her strength and speed to a childhood herding sheep.

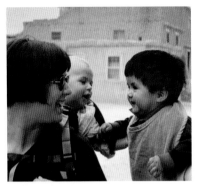
217

Another Easter we spent with Luis Jimenez's family in their old stone schoolhouse in Hondo [219] and celebrated with *cascarones*, hollowed-out eggs filled with confetti. Luis's daughter Xochi was racing around on roller skates, and three-year-old Sam was captivated. There were pheasants, a raven, and the Appaloosa stallion Blackjack, all within the stone-walled former schoolhouse. Luis's accidental death while rigging his rearing horse sculpture for the Denver airport was pure tragedy.

218

◆

In the 1990s, Harmony and I hiked for miles all over the Galisteo Basin in search of Ancestral Pueblo sites.[220] On these early adventures, she carried a broomstick to stomp out the snakes and we rolled up bits of the herb *Osha* in our jeans cuffs to repel them. We both joined the Galisteo Volunteer Fire and Rescue around 1995. She was

219

220

221

222

a real firefighter; I was in the auxiliary. After ten years, she had to leave, but I hung in and am now the oldest member of the GVFR, where I am listed as "reporter." Aside from delivering t-shirts to contributors (and cleaning toilets and flipping hamburgers in the early days), my task is writing about the Galisteo Volunteer Fire and Rescue in *El Puente de Galisteo*, the newsletter I started 26 years ago, still going strong. While I was helping to build the new fire station, learning to lay adobe bricks, I was asked to write something for the occasional one-page *Fireflyer*. Soon after, I was given the go-ahead by the Board of the Galisteo Community Association to start a monthly community newsletter, with the aid, among others, of Barbara and Joe Cooper, Richard Shuff, and Cara Lee, who contributed the handsome logo.

The first issue, in January 1997, was called *La Puente* in a nod to colloquial New Mexican Spanish and to the name of a village road.[221] Indignant responses ensued and it was rapidly changed to the proper *El Puente*. Sponsored each month by a local resident, its roughly regular arrival is taken for granted by villagers. I was relieved to find something I was good at to contribute to the community I was coming to love. There is a surprising amount of news to be reported from this village of around 250 people: local accomplishments, childhood stories from old families, too many obituaries, area history, regional environmental and development issues, and, always, protecting our limited water resources.[222]

◆

224, 225

223

226

Over the years, May Stevens and Rudolf Baranik and I had worked together on endless art political events, so it was exciting when they had a residency at the Wurlitzer Foundation in Taos and fell for New Mexico.[223] They stayed at Harmony's in Galisteo when she was teaching at the University of Arizona and spent one summer in my house. In the late 1990s they moved to nearby El Dorado. Rudolf knew his heart was going to give out after multiple surgeries and told me, now that May was in a place she loved, he could pass on. One March day in 1998, May called and asked casually what was I doing? Working. Well, she said, I think Rudolf died. I rushed over there in a flurry of snow, which he loved. He was sitting in his chair, looking normal. Before he was taken away, May kissed him on the cheek and said "Goodbye, darling." She remained in New Mexico until her death in December 2019, at age 95, her last years spent in a Santa Fe "memory ward."[224, 225] I was her Power of Attorney for seven years — a strange experience, to watch such a close and sharp friend lose herself bit by bit, month by month. But with her former studio assistant,

227

Brandee Caoba, now the curator at SITE Santa Fe, we organized a beautiful show there in spring 2021.[226] May would have loved it, as well as the New York memorial organized by Pat Hills, our friend and her executor, and the little gathering on her birthday at my house in Galisteo when her New Mexico friends took turns scattering her ashes in the Galisteo Creek. We had sent Rudolf's ashes downstream there many years earlier.[227]

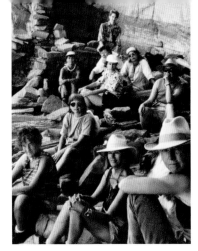

229

◆

I was wildly excited about all the petroglyphs and some pictographs in the Galisteo Basin. (Pueblo people prefer that this often religious or spiritual manifestation not be called rock art, which I respect, though it's a hard term to avoid given the striking quality of many images.) It helped that early on I had met Polly Schaafsma, the doyenne of southwestern rock art.[229] We began hiking to sites around the area and further afield. She and the late lamented Jim Duffield taught me a lot. I learned that the deeper meanings of these extraordinary images are often, and rightly, unknown to outsiders.

230

From a mesa above Abiquiu, with petroglyphs below, Sabra Moore and her husband Roger Mignon built their own compound in a ruggedly beautiful landscape.[230] Sabra, another artist/Heretic in New Mexico, published a little book on petroglyphs and drew more of them for *Down Country: The Tano of the Galisteo Basin,*[231] my book on the Galisteo Basin, finally published in 2010. Sabra runs the Espanola Farmers Market, has sewn costumes for the Santa Fe Opera, directed recycling in Abiquiu, and made

231

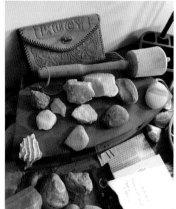

232

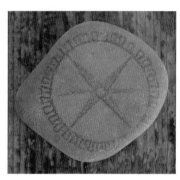

234

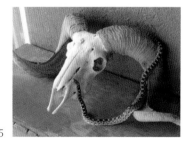

235

a series of exterior mosaic murals with school children at local elementary schools, including those on the pueblos, where she has also tutored.

It isn't just rock art that gets to me, it's the rocks themselves.[232] My house is full of many other stones — on the floor, on windowsills, under tables — souvenirs of forgotten places.[233] I'm not sure when the rock obsession began, but probably in Maine, where interesting things were always washing up on our fine white sand beach. In college I had to take a science course and chose geology. It was taught by a man who had started out as a philosopher, which gave his lectures on the Connecticut River Valley a poetic twist that was not lost on me. Once I began hiking in the west, the offerings expanded, among them a labially suggestive red "desert rose" that has since disappeared. Some are almost art, like a stone painted by artist Katherine Wells, a fellow rock art freak,[234] with an image found on her petroglyph preserve — hopefully on its way to becoming a national monument. Nature is still providing an endless variety, but I get pickier. Now and then I toss out a rock that may have meant something years before but no longer makes the grade; or it was brought in by someone staying at the house. It's a curiously personal choice.

Bones are almost as interesting as stones. Some visiting

little Navajo girls once noted with some apprehension that I had a lot of bones around. A wild sheep's skull on the portal, lightly chewed by a visitor's dog, makes me look like a Georgia O'Keeffe wannabe, but a bull snake's visit made it unique. [235] There are also a snakeskin [238] and some deer antlers (sheds) found on local hikes. I don't feel that these objects are morbid, just memento mori. [236, 237]

Learning New Mexico, its lands and complex cultural histories, is an unending process.[239, 240] Decades ago, I served a term on COLTPAC (a Santa Fe County committee on open space and trails), thanks to encouragement from Kenny Pin and Ed Archuleta. This was an important experience, as was working for years in Galisteo on the county-sponsored village planning committee, and with the working group for the Galisteo Basin Archaeological Sites Protection Act that included significant contributions by Pueblo leaders. Archaeologists Eric Blinman and Linda Cordell and local historian Bill Baxter, among others, continued my education. More recently I'm a pretty useless member of the board of the Galisteo Mutual Domestic Water Consumers Association, where I try and often fail to make sense out of complex hydrological bureaucracies, eco analyses, and engineering projects. Around 2000 I got talked into joining writer Carmella Padilla, and architects Suby Bowden and Gayla Bechtol, among others, in the jurying, design, and construction of Railyard Park in Santa Fe; my old friend and Heretic Mary Miss was half of the winning design team. And today I am on the happily casual

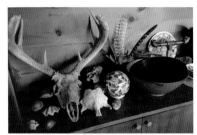

236

237

238

239

240

241

242

board of Axle, a mobile contemporary art van that is one of the liveliest venues in the city. Most of these projects would have been totally alien to the urban activism I cut my teeth on in New York.

My interest in local history grew over the years when I realized there had been no thorough books on either the Galisteo Basin or the village itself.

243

I'd been interviewing elders for decades, and it was time to give their stories a scholarly context. Having been aided by archaeologist Eric Blinman to produce *Down Country*,[241] I then tackled the village itself with help from many local older people and historical archaeologist David Snow. In October 2014, I helped leader Anna Cárdenas and many others organize Galisteo's Bicentennial celebration, which included a walk to the top of The Hill to pay homage to the original settlers, ancestors of current locals. Added attractions were grilled food by the Fire Department and an antique car show organized by our valued local mechanic, Dave Montoya. A short parade included horses and riders, pickup trucks with a guitar player and family heraldry, the Early Morning Walkers carrying a banner, and Denise Lynch on a bike, leading a horse and a nervous Saluki. Afterwards there was a dance in La Sala de San José, with a young rock band from Pecos, and an exhibition of family photographs. Six years later *Pueblo Chico: Land and Lives*

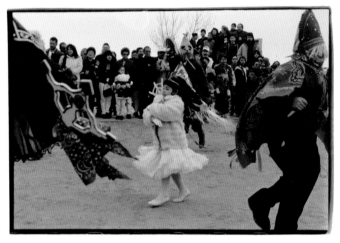

244

245

246

*in the Village of Galisteo Since 1814*[242] came out. My partner thought I should publish it posthumously so I wouldn't get run out of town, but, aside from what was probably muttered behind my back, it has been well received.[243]

Friendships with native New Mexicans beyond the village have been crucial in giving me the courage to write about my adopted home.[244] At a presentation on *Partial Recall* with contributor Cherokee curator Rayna Green at a Connecticut meeting of the Society for Photographic Education in 1994, I met Marxist social anthropologist Jim Faris.[245] He was about to retire back to the Southwest, having spent his first few years at Canyon de Chelly and the rest of his youth at the White Sands National Monument (now National Park) near Alamogordo, where his Park Service father was superintedent.[246] His grandfather had been

[115]

247

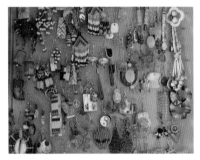

248

249

superintendent of Navajo, Jicarilla Apache, and the Indian School in Santa Fe. After graduating from UNM, Jim got a PhD from Cambridge and has worked in Newfoundland, Sudan, Navajo, and taught in Montreal, Kartoum, Texas, and Connecticut. Once he was in Santa Fe, I wrote a blurb for his book *Navajo and Photography*.[247] We were friends for a few years, then lovers, and now partners for some twenty-three years — to our mutual amazement, a record for both of us.[248] We live separately, half an hour apart, because we both value our independence and were uninterested in moving (and because we'd probably kill each other if we lived together). Jim is a classical music freak, and I am not. My favorite music is whiny Country, down and dirty Black Blues, Bach and Shostakovich, waltzes and anything danceable. He is a dedicated member of Santa Feans for Justice in Palestine — his focal political issue — while my own activism is local, focused won Galisteo.

Jim and I have had many adventures, from visiting his four kids: Matthew in Alaska, Kristin in Delaware, and Michael and Gretchen in Montana [249] (where she and I once tubed down the Blackfoot River), to Spain several times (including a jaunt to the original Galisteo), to Newfoundland, to my talk on an Irish island, to his lecture at Oxford, to South Africa for his tribute at Ben Magubane's 80th birthday symposium, plus Capetown, Table Mountain, Soweto, Mandela's house, to the Mayan jungles, to Kakadu national aboriginal park in northern Australia, to road trips across

[116]

the West, including a long ride to San Francisco and back, partly along Nevada's Highway 50, known as "the loneliest road" in America.

In 2007, I was briefly in New York and got a call from Jan Brooks. Her husband Lane Coulter had to beg off on a long-planned raft trip from Lees Ferry down the Colorado River through the Grand Canyon to Lake Mead.[250] Did I want to take his place? Right now? Yes! I dropped everything and joined up. It was an overwhelming trip, in another world, far from the tourist hubs on the rims above. I wrote about it in the *Harvard Design Review*, where I also published an essay on a controversial campground on our Maine bay which, I was told, pissed off people on both sides of the issue.

◆

In 2009, China the cat was replaced by Chino, a handsome foxy red mutt from the Española shelter, to Jim's relief.[251] (He is the second Scorpio allergic to cats I've been with, and he had put up with China for close to a decade.) Having lost his sweet Rez Dog, he came to Espanola the same day and adopted Chino's adored stepbrother, Yazzie (it means small in Navajo, but he turned out to be younger than they said and grew out of short). Chino had been a stray in Espanola for a few months and was very streetwise. He was also a counter surfer (I once found him standing on the dining table delicately prying chocolates out of a closed box). A chewer of checks and other papers, he enjoyed snacks of manure from next door, and at one point he developed a bad habit of ferociously barking at anyone

250

251

252

254, 255

253

coming in the house, familiar or not, then persistently nudging them to pet him. His longest and most beloved sitter was Walt Stevens,[252] actor, painter, singer, dancer (best known as the star of Bruce Nauman's 1987 *Clown Torture*), who left a painting for me one summer.

◆

Years ago a Jehovah's Witness proselytizer came to my door and, peering in, got the impression I was religious because he could see several crosses,[253] plus a crucifixion from Haiti draped with a string of dried apples,[254] a gift from artist Mira Burack, who is helping me figure out my archives and clear out my thousands of books and papers. In fact, I am an atheist, though, after several strange experiences and charting my dreams for several years, I must acknowledge that some incomprehensible energy exists beyond our ken. But, even as an unbeliever, I am susceptible to heartfelt religious objects. Two elegant

257, 258

256

crosses with straw inlay (aka Poor Man's Gold), are by our Galisteo Fire Chief, Jean Anaya Moya, a prize-winning *santera*. And another New Mexican, witty *santero* Nick Herrera, made *San Gregorio*.[255] One of the more elaborate pieces is from Ethiopia, where my aunt Betsy and uncle Chuck Langmuir lived and worked from 1966 to 1972.[256] On weekends they shopped around the countryside, always offering their finds first to the national museum, where she volunteered. The museum was rarely interested, so theirprivate collection grew. Some pieces were passed on to relatives while others form the core of the Langmuir collection at the Peabody Essex Museum. I ended up with two beautiful little Coptic paintings and several crosses and cross-like keys. [257, 258]

◆

Having worked on books with Ed Ranney, Peter Goin, and Native photographers, I found myself increasingly involved

259

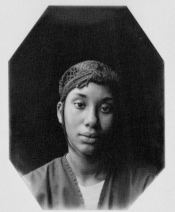

262

260

263

in photography with its real-world potential and often stunning views of western land — especially critical landscape photography that sometimes belies its tragic content with sheer beauty. In the mid 2000s, I was ready to start another book but swore this one would be short. It was sparked by a conversation I had about gravel pits with Jim Sloan, Galisteo artist/earthmover/snake savior. This led to a lecture for a British conference on cities and then to *Undermining: A Wild Ride Through Land Use, Politics, and Art in the Changing West*, [259] in which I rethought my previous views on landscape and land art in favor of cultural land use. Some of it was informed by New Mexico anthropologist and friend Sylvia Rodriguez's book on the *acequias* (the hand-dug irrigation ditches that made farming in arid New Mexico possible from its beginnings) and Sharon Stewart's photoseries on the annual ditch cleanings in the tiny village of El Cerrito.[260] She lives in the rural village

264

265

266

of Chacon in Mora County, and is part of *Going with the Flow*, a 2023 exhibition on regional art and water I am co-curating with SITE Santa Fe's Brandee Caoba.

◆

I was back in the Grand Canyon (on the rim this time) in 2017 for my 80th birthday. After a dinner at Harmony Hammond's,[262] hanging out with visitors Susana Torre and Geoff Fox, Betsy Hess and Peter Biskind, and a big outdoor party in Galisteo with a motley crew of friends,[263] including several Heretics, the family (Jim and I, Ethan, Kyla, Sam and Calvin) took off on a road trip to the Grand Canyon—the best of all possible celebrations.[264] We stopped on the way at Acoma Pueblo, the Meteor Crater, Wupatki, Flagstaff, the Little Colorado, and other amazing places, Sam doing some of the driving. At the Canyon we hiked according to our capacities, though none of us made it all the way down to the river. Teen-aged Calvin, clumsy in new boots, kept balancing on the edges of cliffs. Sam walked with me; we were scared to watch. Ethan kept bragging to people that I was eighty and still hiking. He and I had been to the Grand Canyon with Charles in the 1970s. I vividly remember a big buck deer passing in the snow in front of our tent, but all he remembers is getting a great comic book.

In June that year, on what was once an annual road trip to Montana to see Jim's kids, we took a gentle hike near the Blackfoot River where both live. I stepped up an easy rock shelf and my left knee shrieked and gave out. I can still walk an hour a day with the dogs, and more if I'm distracted, but

my long hiking days were over. It hurts to walk, but it hasn't gotten much worse over six years. Surgery isn't as scary as the long rehab.

In 2018 Harmony Hammond, Betsy Hess, Jan Brooks, and I traveled to Spain,[265] beginning with a visit to Susana Torre in Carboneras, and going on to Granada and Cordova,[266] then splitting up so Betsy and I could return to Madrid, where I spoke at the Reina Sofia. We had a lovely nostalgic dinner with Cesar Paternosto and Luis Camnitzer from the old NYC days and met with the women from Consonni who had published the translation of *I See/You Mean (Yo Veo/Tu Significas)*. My neighbor Peggy Diggs is an avid traveler, and in the fall of 2019 she and I went to Brazil for a gig of mine in Sao Paulo, traveling by bus to beautiful cobblestoned Paraty where we hired a boat to tour the fiords in the rain, and finally to the dynamic city of Rio, where we stayed in the elegant apartment of artist Josely Carvalho, an old friend from NYC and *Artists Call* colleague, surrounded by her eerily beautiful glass smell sculptures.

Also in the fall of 2019, Jim and I had a delightful working visit to Juarez, and in February 2020, just before the pandemic struck, we went to Mexico City for an exhibition of Chilean poet/artist Cecilia Vicuña, an old friend in New York. With Cecilia and her partner, another Jim, we had a blissful day at Teotihuacan, which I hadn't seen since the 1950s. At home, the eagle whistle[267] I bought there is kept company by a Mexican folk art piece of a bobble-head eagle with a snake in its mouth perched on a cactus, bought

267

268

269

270

271

272

273

at the annual Metamorfosis Documentation Project sale put on by friends Craig Johnson and Armando Espinosa Prieto, who travel to various small indigenous communities in Mexico, helping out and bringing back amazing objects for their annual sale, the proceeds of which are shared with the original communities.[268]

Then the pandemic struck.[269] Jim and I got light cases of covid months apart, despite endless shots and precautions. For two years our travel was reduced to weekly Sunday pandemic trips around New Mexico's perilous dirt roads, amazed at what lies in our backyard.[270, 271] Despite approaches from both east and west, we never did find the elusive town of Dahlia; it's on the map, but unreachable according to those we flagged down for help. Once, as we drove through a deep arroyo, a pickup truck stopped us

[124]

and the driver warned that this was "bad country" with "bad people." We have had some exciting moments on virtually impassable roads with no place to turn around and flee, but never any trouble from local folks despite frequent trespassing. [273]

274

Through forests and arroyos, plunging down into narrow fertile valleys, we mourned the many crumbling homesteads and admired the persistence and beauty of these tiny old villages, so many of which were devastated in the 2022 Hermit's Peak/Calf Canyon wildfires. [272, 274] Whenever possible we stop at the Villanueva General Store for delicious Mexican popsicles.

◆

The year 2020 was one of loss, first of my beautiful Zuni ring from Jim, in a supermarket parking lot; then in the fall, as though that year were not bad enough already, after over eleven happy years as my constant companion, Chino was killed by a car speeding from a movie set on September 18, breaking my heart forever. [275] Perhaps he accompanied RBG, who died the same day. We buried him near China in my yard. (Yes, he was named after a cat, but in New Mexican Norteño dialect *chino* means stranger, or curly.) I find it painful to live without a furry creature in the house. Chino was briefly replaced by a sweet geriatric pup named Tano (aka Bumblefoot). [276] Blind, deaf, and stumbling, he

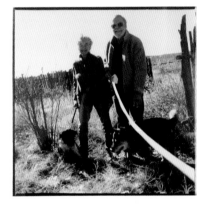

276

277

278

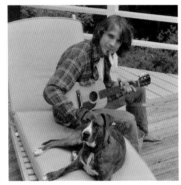

279

280

only lasted six months before he started having seizures, probably due to a brain tumor, and was painlessly put down with his head in my lap. (We should all be so lucky.) I gave him a happy end of life and he taught me some patience. Better late than never.

It was lonely without Chino. Finally, after months of checking out thousands of dog pictures on line, plus shelter visits, I found a keeper in Albuquerque, thanks to the urging of my neighbor Angie Heath. Tanita (aka Tana, TaTa, Titalita) is a brown and white spotted Red Heeler, or Australian cattle dog, who is probably smarter and certainly a lot more energetic than I am. [277] A former ranch dog, eleven years old (going on two), she runs like the wind, chases everything moving, and is (mostly) obedient. She has taken over the couch and hops up into the high window seat like a cat. When my grandsons visit, her love-sponge proclivities compete with their initial priorities: the landscape and the food. [278, 279]

My writing takes me all over the place. During the five months when I was finally trying to finish this book, my writing jobs included essays on Gene Beery, Leo Amino, Peruvian *huacas,* nostalgic feminism, Ad Reinhardt, Alexis Rockman [280] and Mark Dion, Chicano art, Nancy Sutor . . . and other odds and ends. This kind of variety, typical of a working journalist (or hack), keeps me intrigued and on my toes. When I'm asked how I deal with writer's block, I laugh. I don't entertain that luxury. This is how I make my living.

[126]

281

282

◆

283

285

Where does this story end? Where will all this stuff end up? Who knows? It's a strange time of life, mid-eighties. Do I have time for another book, a long-planned collection of essays on monuments and contested histories? Or is this the last one? A couple of years ago I heard from someone in Europe that they meant to ask me to write something, but they heard that I was "elderly and semi-retired." I responded that I was *old*, not elderly, not retired, not yet ... [282-285]

284

And still so much stuff. Some 200 boxes have been sent off to the Archives of American Art, libraries, schools, prisons, historical societies, the Nevada Museum's Center for Art + Environment, and thousands of books to any place that will take them, given the sad fact that libraries are having their spaces cut in favor of digitization. All this thanks to the ongoing efforts of Mira Burack (and her predecessor John McKissick). So how come the desk and workroom are still overflowing? [281]

Increasingly often friends ask me and Jim "what are your plans?" I always say I don't have any because I have no idea what I'm planning for. [286] And we've heard that when people make plans, the gods laugh. Should we stay awake at night fantasizing about all the dire contingencies? We both have heirs. I have one son, two grandsons; Jim has two sons and two daughters, five grandchildren, and a great grandson. In 2021, when the clan gathered for his 85th birthday, his four offspring cornered him, and under duress he made those dreaded plans, moving into independent living at a classy retirement home in downtown Santa Fe. Downsizing was traumatic for all concerned. As for me, I still have no plans, continuing to hope that I leave Galisteo feet first. If I can't read and can't walk, please shoot me. In the meantime, I'll keep writing because it's all I know how to do. [287]

*Galisteo, March 2023*

286

287>

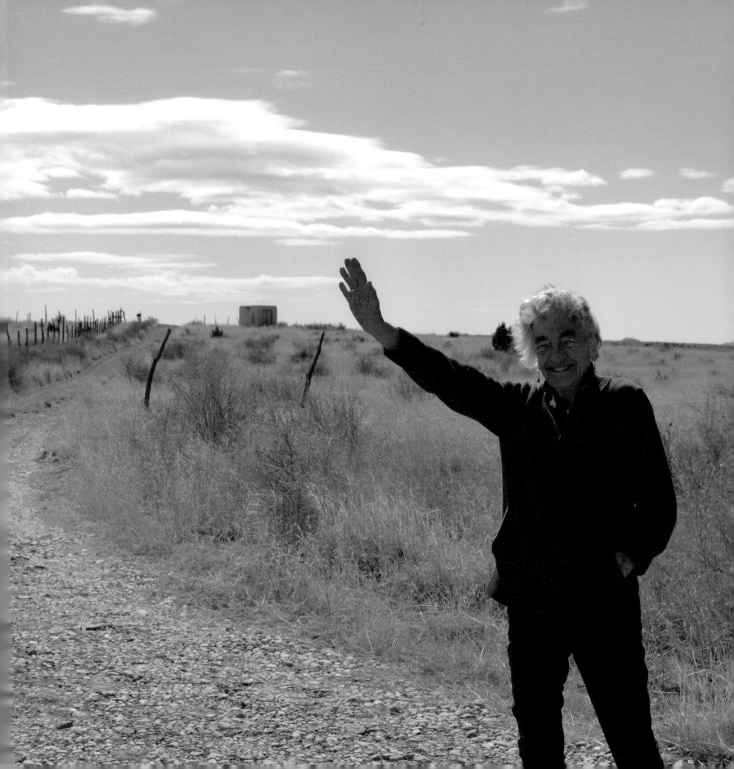

288

## ACKNOWLEDGMENTS

First and foremost, thanks go to my amanuensis Mira Burack, to designer and raconteur Michael Motley, and to Lynne Elizabeth of the New Village Press for accepting this project on faith despite its unorthodox process. Without their patience this book would never have come to fruition. And my gratitude to all the artists who kindly gifted me works; to Jim Faris and Ethan Ryman for love and support. Though so many friends are not mentioned here in this object-oriented text, I am still learning from them, especially those who are native or longtime New Mexicans, too many to mention... but you know who you are. *Mil gracias.*

# ILLUSTRATION NOTES

*Unless otherwise noted, the in-house images and re-photographs were primarily taken by Mira Burack, as well as some by Chip DIllon. Other images, unless noted, are by Ethan Ryman and the author.*

Front cover: Sunday Morning. Photo: LRL.

Back cover: LRL's political buttons, exhibited in a glass case on the outside wall of a saloon in Willard, New Mexico, 2021.

Frontispiece: Afternoon light on a window seat shelf. Photo: LRL.

Dedication page: Bookcase in the guest room with fan, an old map of Ohio earthworks, Christy Rupp cutout, Sabra Moore (*Leaves*, 1988), and lots of other stuff.

i. Looking up the driveway at 14 Avenida Vieja, Galisteo.

ii. Looking down from the sleeping loft.

iii. Bookshelves and boxes in workroom.

iv. Guestroom.

v. Summer view to patio and bosque.

1. Telephone wire spool table, found in the Galisteo Creek bed as my house was being built

2. Sol LeWitt, coffee table, 1961.

3. The window seat.

5. Kiva fireplace.

4. Nicho above fireplace.

6. Hopi pot (broken and restored); plaque by Darlene Nampeyo (Hopi/Tewa), 2019.

7. Calvin and Sam Ryman in our now sixty-year-old outboard, Kennebec Point, c. 2006.

8. Sam Ryman, *Black Hole*, c. 2001.

9. Calvin Ryman, *To Grama Marry Christmas*, c. 2009. (As a child Calvin was obsessed with the Titanic; he built a big wooden one, which ceremoniously "went down" in the Prince Street elevator one commemorative April 15th. Left on the street corner, it was immediately grabbed — no doubt by a discerning art collector.)

10. George Freeman, *Isham Family Portrait*, paint on ivory, 1853-54; fan with tourist stickers.

11. Frank Worthington Isham.

12. Mary Rowland Isham.

13. Frank, Christina, Mary holding Ethel, Florence, Margaret and Mary with dolls, in living room at LC Ranch, Horse Creek, Wyoming, 1889.

14. Florence Emily Isham at an early age, photo on metal disk.

15, 16. Roselle T. Cross and Emma Bridgman Cross from *The Home Missionary*, 1896.

17. Portrait of "Little Thedie" (Theodore R. Cross), pencil, n.d. Roselle and Emma's first child, who died at age three in Hamilton, NY. Artist unknown, possibly his mother.

18. Hand-colored photograph of the pseudo-Swiss chalet in Manitou Springs, Colorado, home of Dr. John B. Isham, a physician for the railroad, and his wife Jane, 1891.

19. Florence Emily Isham's Colorado College scrapbook, 1898–1901.

20. The Minerva Society at Colorado College, c. 1900. (Florence Isham, back row, third from left.)

21. *Pike's Peak Nugget*, Colorado College yearbook, 1901. Illustrations by Florence Isham.

22. Christina and Florence Isham on Stockings and Ribbon, Wyoming, early 1890s.

23. Rowland family home at 42 Academy Street, New Haven, Connecticut.

24. Florence Rowland in blackface as Prissy, in a historical play commemorating the lives of Daniel Wooster and his wife, Mary, Center Church House, New Haven, 1914.

25. Silhouette of Edward Rowland Sr., owner of 42 Academy St., c. 1860s.

26. Stamp box from Grace Hibbard, 1889.

27. Florence Emily Isham, *Shell*, c. 1902.

28. "President Cross Retires," *The Tougaloo News*, May 1947.

29. Judson Cross Hall, Women's Dormitory at Tougaloo College, Jackson, Mississippi, 1940s.

30. Margaret (b. 1907), Elizabeth, and Judson Cross, c. 1913.

31. High Tide, Kennebec Point, Georgetown, Maine.

32. Will, Lucy, and baby Vernon William Lippard, c. 1905.

33. "Forget Me Not," Lucy Balcom's autograph book, Nova Scotia, c. 1890s.

34. Vernon Lippard (second row, far right) on high school football team, Marlborough, Massachusetts, c. 1921.

35. Unknown artist, portrait of Margaret (Peg) Lippard in Paris, 1927–28.

36. Vernon Lippard and Margaret Isham Cross on the steps at High Tide, c. 1931.

37. Margaret Isham Cross Lippard, Winchester, Massachusetts, 1931.

38. Baby Lucy Rowland Lippard (LRL), 1937.

39. Lippard house on Kennebec Point, Georgetown, Maine, built 1939. (Architect: "Red" Owens.)

40. LRL on Kennebec Point, c. 1944. Photo: Charles Langmuir.

41. Vernon with his parents, Will and Lucy Balcom Lippard, 1943.

42. Vernon Lippard, *Island Hospital, South Pacific*, watercolor, c. 1944.

43. "New Guinea Pig," wood, brought back from South Pacific by V.W. Lippard; on right, brass buffalo from the Isham family.

44. Margaret Lippard, *Seguin Lighthouse*, watercolor, 1950s.

45. Vernon Lippard, *Tide Out in Sagadahoc Bay*, oil on board, 1960s.

46. Margaret Lippard (above) and Vernon Lippard (below), watercolors, *New Harbor, Maine*, 1950s.

48. Molly Slappy, *Horse Drawings with Jack Mule*, embroidery on fabric, c. 1949. Molly worked for us in New Orleans and made this for my birthday, secretly taking images from my horse books, and adding the mule.

49. *The Lone Ranger and Tonto*, tin advertisement for Merita Bread and the Lone Ranger Safety Club, 1940s.

50. A black and white spotted ceramic, the only survivor of my horse model collection, and a recent spotted clay horse by the late Priscilla Hoback, a Galisteo ceramist/ equestrian, from her daughter, Denise Lynch.

51. LRL on Lady Be Good in Virginia horse show, c. 1952.

52. Two of LRL's equestrian trophies (fox goblets), Virginia, 1951, 1952.

53. LRL dancing with Daddy, c. 1954.

54. Dr. Vernon W. Lippard with medical colleagues and President Dwight Eisenhower at the White House, Washington DC, 1954, event unknown. VWL was a devoted Democrat.

55. LRL and Graham Wren preparing for his Senior prom, Medford, Massachusetts, 1953.

56. Tapestry embroidered by nuns in Chad, Africa, after precolonial cave drawings. Gift to my parents from a New Haven neighbor who had worked in Chad.

57. Haven House, Smith College, Northampton, Massachusetts.

58. Postcard from LRL in Colorado to parents, on 1956 summer road trip.

59. LRL and Jacques, Aix on Provence, Fall, 1956.

60. LRL and Werner Buser, Paris, Spring, 1957.

61. Lucy R. Lippard, *Sea Cliff*, woodcut, 1950s.

62. Lucy R. Lippard, *Storm at Sea*, woodcut, 1950s.

63. José Guadalupe Posada, *La Calavera Catrina*, zinc etching, 1910–1913 (reprint). Originally intended as a satire on upper-class women during the Porfirio regime, it has since become an iconic Day of the Dead image. I bought this in Mexico, Summer, 1958.

64. Semei Morales; San Salvador El Verde, Puebla, Mexico, c. 2002.

65. LRL in Max Ernst exhibition, Museum of Modern Art, New York, 1961.

66. Lucy R. Lippard, *Pop Art*, New York: Frederick A. Praeger, 1966; Lucy R. Lippard (editor) *Surrealists on Art*, 1970, and *Dadas on Art*, 1971, Englewood, New Jersey: Prentice-Hall; *Dadas* was reprinted by Dover Books in 2007. Lucy R. Lippard, *The Graphic Work of Philip Evergood*, New York: Crown Publishers, 1966.

67. Louise Bourgeois, *Untitled*, ink drawing, gift of the artist, c. 1967.

68. Basket of political buttons acquired and worn over the years.

69. *I'm My Own Person, Lucy*, Peanuts cartoon, felt banner on door of LRL's bedroom/study on Kennebec Point

70. LRL and Judy Chicago with Elvis at Ryman Auditorium, Nashville, Tennessee, 2006. Photo: Donald Woodman.

71. Robert Ryman in his Bowery studio, 1964. Unpublished photo by *The New York Times*.

72. LRL with wildflower bouquet of Queen Anne's Lace and Robert Tracy Ryman at Kennebec Point, wedding, August 19th, 1961.

73. Robert Ryman, *Yellow Drawing #9*, graphite, pastel and ink, c. 1963.

74. Pregnant LRL taking notes in a New York gallery for a review in *Art International*, 1964. Photo: Ray Parker.

75. *Bonzo*, mounted buffalo head found by Bob Ryman and Ray Donarski in empty loft on the Bowery, c. 1962.

76. Ryman, Donarski, and LRL, *Mona Lisa New York City 1963*, metal button.

77. LRL and Robert Ryman in Jim Rosenquist's studio, c. 1963.

78. Sol LeWitt, drawing on cover of *Changing*, 1969.

79. Lucy R. Lippard, *Changing: essays in art criticism*, New York: E.P. Dutton, 1971.

80. Robert Ryman and newborn son, Ethan Isham Ryman, in Bowery loft, 1964; unpublished photo by *The New York Times*. Tom Doyle sculpture at left, unstretched Ryman at right.

81. Ethan Ryman, watercolor, c. 1970. I interpret this as a prenatal memory, probably dubious.

82. Eva Hesse, *Untitled*, pen and ink wash, 1961. She gave me a similar drawing for my birthday around 1968, and I traded it for this one, which I liked better because it seemed closer to her mature work.

83. Ad Reinhardt, *No War*, for *The Collage of Indignation*, Artists and Writers Protest, 1967.

84. Lucy R. Lippard, *Ad Reinhardt*, New York: Harry N. Abrams, 1981.

85. John Chandler and Ethan Ryman in photo booth, c. 1967.

86. Ethan Ryman at a downtown performance with LRL, 1973. Photo: Linda Lindroth, from a proof sheet.

87. Happy Ethan, c. 1967. Photo: Alejandro Puente.

88. Edward Ranney, *Throne of the Inca, the Rodadero, Cusco*, 1975. See also #215, Peruvian "grave dolls" made from excavated textiles, acquired on my 1968 trip.

89. Edward Ranney (text by Lucy R. Lippard) *The Lines*, New Haven: Yale University Press, 2014.

90. 138 Prince Street, fifth floor, Lippard/Ryman loft since Fall, 1968.

91. Alex Katz, *Ethan Ryman*, pencil, c. 1969.

92. Henry Pearson, *Untitled*, altered postcard, c. 1969.

93. Sol LeWitt, *Wall Drawing* (detail) in LRL's Prince Street loft, c. 1970. Photo: Courtesy of the LeWitt Foundation.

94. Ethan Ryman, *Hamburger and Spider*, c. 1973.

95. Ethan Ryman, *Safari Man*, c. 1974. Ethan made this in school; the hat got broken and is replaced by a deteriorating papier-maché fedora inherited from my grandparents, a perfect fit; a label inside notes: "Made of the US greenbacks redeemed and macerated by the US Government at Washington D C. Estimated at $5,000."

96. LRL leafletting during an Attica protest at the Museum of Modern Art, 1971. Photo: Jan van Raay

97. LRL and members of the Art Workers Coalition demonstrating for the creation of an admission-free day at the Museum of Modern Art, New York, January 1971. Photo: Jan van Raay.

98. Lieutenant Calley mask worn at an anti-war demonstration in Washington DC to remind viewers about the My Lai Massacre, 1969. A crowd of us wore this mask to declare that we were all complicit with Calley, because we were all responsible for not stopping the war. Some misread our action as identifying with Calley's murderous actions.

99. Seth Siegelaub next to policeman at an anti-war protest at the Museum of Modern Art, 1969. Photo: Mehdi Khonsari.

100. LRL, cards as catalogue for my first two "numbers shows" in Seattle (*557,087*, 1969) and Vancouver (*955,000*, 1970).

101. Iain Baxter/N.E. Thing Co., exhibition poster; LRL in airport during 1969 art trip to the Arctic Circle.

102. Postcard of Carboneras, Almeria, Spain, c. 1970.

103. Lucy R. Lippard, *I See/You Mean*, Los Angeles: Chrysalis Books, 1979; reprinted by New Documents, Los Angeles, 2021; Spanish translation by Paloma Checa-Gismero, *Yo Veo/Tu Significas*, Bilbao: Consonni, 2016.

104. Lucy R. Lippard, *A Different War: Vietnam in Art*, Seattle: Real Comet Press/Whatcom Museum of History and Art, 1990.

105. Eva Hesse, postcard to LRL, 1967.

106. Lucy R. Lippard, *Eva Hesse*, New York: New York University Press, 1976; reprinted by Da Capo,1992; Spanish translation by Juan Elias Tovar and Sonia Verjofsky, Mexico City: Alias, 2017.

107. Lucy R Lippard, *Six Years: The Dematerialization of the Art Object...*, New York: Praeger. 1973; reprinted with new preface by University of California Press, Berkeley, 1997; translated into Spanish as *Seis Años: La Desmaterializacion del objeto artistico de 1966 a 1972*, Madrid: Ediciones Akal (Arte Contemporanea 14), 2004; Catherine Morris and Vincent Bonin, eds., *Materializing Six Years: Lucy Lippard and the Emergence of Conceptual Art*, Cambridge: MIT Press/Brooklyn Museum, 2012.

108. *50%*, slide, 1970, projected on the façade of the Whitney Museum along with slides of women's art during Ad Hoc Women Artists Committee protest at the opening of the Whitney Annual.

109. LRL cutting cake at the Los Angeles Woman's Building, mid 1970s. Photo: Maria Karas.

110. *26 Contemporary Women Artists*, Ridgefield, Connecticut: Aldrich Contemporary Art Museum, 1971.

111. *52 Artists: A Feminist Milestone*, 2022, Ridgefield, Connecticut: Aldrich Contemporary Art Museum, 2022.

112. Lucy R. Lippard, *From the Center: Feminist Essays on Women's Art*, New York: E.P. Dutton, 1976.

113. *The Pink Glass Swan: Selected Feminist Essays on Art*, New York: The New Press, 1995.

114. LRL installing *Both Sides Now*, exhibition of women's art at the Artemesia Gallery, Chicago, 1979.

115. Irving Petlin, LRL, Leon Golub, and little Ethan (further to right, leaning over) at protest of the cancellation of Hans Haacke's exhibition at the Guggenheim Museum, 1971. Photo: Jan van Raay.

116. Charles Simonds, *A Home for Wayward Little People on Your Window Ledge*, clay plaque, c. 1979. The promised birthday present was never executed, but in 1998 Simonds made a dwelling in the courtyard of the New Mexico Museum of Art as part of the *Sniper's Nest* exhibition of LRL's donations to the museum.

117. The Phalarope (Drascombe Lugger) at the mouth of the Kennebec River, Fort Popham in the background, c. 1975.

118. LRL sailing Rosita (Beetle Cat), Sagadahoc Bay, Maine, c. 1985.

119. Charles Simonds, inauguration of La Placita (aka Charles Park), East 2nd St, New York, 1974.

120. Charles Simonds and Lucy R. Lippard, *Cracking*, originally published in German in 1979 and then in English in 2016, both by Verlag der Buchhandlung Walther König in Köln.

121. Ruins at Chaco Canyon, New Mexico, c. 1995. Photo: Peter Woodruff.

122. Peter Goin (text by Lucy R. Lippard), *Time and Time Again: History, Rephotography, and Preservation in the Chaco World*, Santa Fe: Museum of New Mexico Press, 2013.

123. Toni Robertson, *Where Do Correct Ideas Come From?* color screenprint by Earthworks Poster Collective, for the Marxism Feminism Conference, Sydney, Australia, 1977. "Do they drop from the skies? No. Are they innate in the mind? No. They come from social practice. Pure theory, pure shit. Egghead feminists and other useless theorists get fucked!"

124.Vivienne Binns, *Combing the Surface*, acrylic on board, 2009.

125. Annie Newmarch, 1970s.

126. John Fekner, *Our Children's Drawings Are Historical Documents*, Printed Matter window on Lispenard Street, c. 1984. With few exceptions, my extensive collection of artists books is no longer in the house, leaving a big hole in the "stuff." It was recently donated to the New Mexico Museum of Art.

127. *Heresies* #1, 1977.

128. *Earthkeeping/Earthshaking; Feminism & Ecology*, *Heresies* #13, 1981.

129. Christine Oatman, *Elephant with Butterfly Ears*, collaged card, 2022, one of many of the reclusive San Diego artist's lyrical postcard and sticker pieces that she has sent over the years; Anne Noggle, *Stonehenge Decoded*, 1977, one of my favorite feminist images years ago; the photograph is a recent gift from my friend photographer Martha Strawn who is handling Noggle's estate; Janet Russek, *Not One More*, Archival inkjet print, 2018; *Sisters*: Saint Lucy (from Betsy Hess) and La Puta (from Harmony Hammond); LRL (aka Lucy the Lip), *Polly Tickle*, early 1980s.

130. Hand-me-down boots from Suzanne Lacy.

131. Avis Fleming, *Horses and Barn (Aladdin's Africa)*, stone lithograph, 2015. (Avis has been a friend since childhood. Originally from Louisiana, she is an artist in Washington D.C. and summers, like me, in Maine.)

132. Boardwalk as Uroboros. Ethan wanted a snake, but when I was confronted with reptiles at a pet store, I couldn't do it. So we got an Iguana he named Boardwalk. Later we did bring a poor little green garter snake from Maine and named it Park Place. This was a bad idea, and we let him loose, so he became Central Park Place. Years later, when Boardwalk died, Charles epoxied him as a uroboros that hangs in his studio.

133. LRL and Gnasher at Ashwell Farm, Devon, England, 1978. Gnasher, the border collie, was named by the Boyces after a comic book character. Photo: Gioia Timpanelli.

134. Ti Parks, *Ashwell Farm*, pen and colored pencil, 1978. Made by a visiting artist friend. On the right is the cottage in which Ethan and I spent a year, and at the left is Gnasher.

135. *Stonehenge*, a page torn from an eighteenth-century French book. The surrounding landscape is not accurate. My many slides of the Dartmoor and other sites were too poor to reproduce.

136. *Silbury Hill*, 1978. This neolithic chalk and clay mound in Wiltshire County, England, was constructed in phases, c. 2400–2300 BCE. At 130' high, it is one of the largest human-made mounds in the world and may be associated with Avebury and Stonehenge. Photo: LRL.

137. Lucy R. Lippard, *Overlay: Contemporary Art and the Art of Prehistory*, New York: Pantheon, 1983; reprinted by The New Press, 1994.

138. Michelle Stuart, *Avebury, Wiltshire, England*, photographs and earth from the site rubbed on paper, 1980–81.

139. Ethan Ryman on the box for Honeycomb cereal, c. 1974.

140. Ethan Ryman in school play at Elizabeth Irwin High School, New York, c. 1982.

141. Ethan Ryman's headshot for the Screen Actors Guild, c. 1983.

142. *The Box*, Ethan Ryman (center front row) at his Hip Hop Studio on Lower Broadway, including his school friends Daniel Whitney (back row right) and Max Becher (front row, left of Ethan), c.1984.

143. Jerry Kearns, *Broken Promises, Active Resistance*, 1980. The stenciled mural in the South Bronx was by John Fekner.

144. Jerry Kearns and LRL performing *My Place, Your Place, Our Place*, Franklin Furnace, New York, 1982.

145. Jerry Kearns and Lucy R. Lippard, *Tense*, unfinished version of comic book from the early 1980s, published by Anne Turyn's *Top Stories*, Amsterdam: Kunstverein Publishing, 2021.

146. *Upfront* "Lower East Side, Portal to America," 1980.

147. Greg Sholette, *NEA Chairman* (The Administrators Series: Frank Hodsoll), plastic model kit, 1981. Hodsoll, a Reagan appointee, vetoed modest grants to PAD/D and *Heresies* that had been approved by the selection panels, foreshadowing the pending Culture Wars.

148. Mike Glier, *Give Blood*, temporary mural in *Who's Laffin' Now?* exhibition at District 1199 Gallery, New York, c.1982.

149. *Vigilance*, show of artists books curated by Mike Glier and LRL, Franklin Furnace, New York, 1979. The banner is a quote from Antonio Gramsci: "pessimism of the intellect, optimism of the will."

150. Grace Williams, *Mask*, from *Working Women* show at District 1199 Gallery, New York, 1982.

151. Ricardo Levins Morales, *Nothing About Us Without Us Is For Us*, poster, c.2005.

152. Anonymous Chinese artist, *Landscape Scroll*, Shanghai, 1980.

153. Christy Rupp, *Fish* (deformed by pollution), mixed media on cardboard,1981–84; *Green Leaves*, painted cardboard, early 1980s, created for a fundraiser or poetry reading.

154. *Weather Report: Art and Climate Change*, exhibition curated by Lucy R. Lippard at the Boulder Museum of Contemporary Art, 2007.

155. Ana Mendieta's clay pot with hammer and sickle painted on it, c. 1983.

156. Cuban artworkers visiting New York, in May Stevens' loft, 1985. Left to right, back row: May Stevens, Jayne Cortez, Cecilia Vicuña, (unknown), Ana Mendieta, Gerardo Mosquera, Vivian Browne, Mel Edwards, Aaron Rosen (?), Irving Petlin. Front row: José Bedia, Cesar Paternosto, Ricardo Rodriguez Brey, Flavio Garciandia, Rudolf Baranik, LRL. Photo: Clarissa Sligh.

157. Natasha Mayers, *Banksters*, acrylic, 2015.

158. Noah Apple, *WMDs: Nuclear, Biological, Chemical*, painted cardboard, 2004.

159. Kay Walkingstick (Cherokee), *#121*, acrylic and saponified wax ground with dry media on top, 1980; Jaune Quick-to-See Smith, (Salish Kootenai Nation), *Salish Home*, magazine paper collage, acrylic paint, and ink, 2001; Ron Noganosh (Anishinabe), *JARYL*, plastic, 1982; Feather headdress from the Amazon, gift of MaLin Wilson and Greg Powell; T.C., Kachina from Jemez Pueblo, 2012; Hulleah Tsinhnahjinnie (Seminole/Muscogee/Navajo), *Damn*, 1998.

159A Pueblo fetishes: gifts and collected over the years. If I were richer, I'd have dozens of these marvelous objects, most of which are by artists from Zuni Pueblo.

160. Jaune Quick-to-see Smith, (Salish Kootenai Nation) from *Paper Dolls for a Post-Columbian World*, 1991, cover of *How to '92*, an action handbook for the Columbus Quincentenary.

161. Lucy R. Lippard, *Partial Recall: Photographs of Native North Americans*, New York: The New Press, 1992.

162. Jimmie Durham (Cherokee), *Armadillo*, painted skull with mixed media (damaged), c. 1980.

163. Lucy R. Lippard (image by Jerry Kearns), Untitled, *Village Voice*, Sept. 10, 1981, with Ethan in his Police t-shirt playing the piano, Kevin Lynch of the IRA, who had just died in jail on a hunger strike, and right winger Curtis Sliwa, founder of the Guardian Angels.

164. Lucy R. Lippard and Jerry Kearns, "Happy NewsYear," *Village Voice*, Jan. 1, 1985.

165. Artists Call/PAD/D, *Pacman: I can't believe I ate it all*, made for demonstration in Washington D.C. protesting U.S. Intervention in Central America, 1984.

166. Lucy R. Lippard, *Get the Message: A Decade of Art for Social Change*, New York: E.P. Dutton, 1984. The cover is Suzanne Lacy's and Leslie Labowitz's Wailing

Women, *In Mourning and In Rage*, performance on domestic violence, Los Angeles, 1977.

167. Ethan Ryman, *Percent Descent* (AP 1/2), archival pigment inkjet prints on paper, plexiglass panels, binder clips, 2006.

168. Ethan Ryman, *Untitled Convergence 121,* archival pigment inkjet print on laminate box, 2012.

169. Ethan Ryman, *Performer Triptych,* archival pigment inkjet prints on laminate boxes, 2011.

170. Ethan Ryman, *Roland Barthes*, pen and ink, Christmas, 2018.

171. Max Becher and Andrea Robbins, *Havana Blackout*, photograph, 1993.

172. LRL, Daniel Flores y Ascencio, and Leon Golub, Artists Call panel at Judson Memorial Church, New York, 1984.

173. Peter Gourfain, Artist's Call button, 1983.

174. Peter Gourfain, ceramic necklace and carved wooden plane, 1984.

175. Jack Levine, *Barrio Jonathan González, Managua, Nicaragua*,1983. Inscribed: "This is a revolution Emma Goldman would have liked."

176. Photographer unknown, Nicaraguan children with mural, 1984.

177. Noah Jemison and LRL, 1984.

178. Nicaraguan Mask, an icon of media coverage of the Central American wars.

179. Ethan Ryman reading the names of *desaparecidos* from Central America, at the end of Artists Call's Procession for Peace, Washington Square, New York, 1984.

180. Margaret I. Lippard, *The Wild Flowers of Georgetown Island*, 1981. Front and back covers by Ellen Lanyon.

180A. Ellen Lanyon, *A Time of Bliss*, c. 1986, a gift when I was leaving for five months in Colorado.

181. Sisters Peg Lippard and Betsy Langmuir at the Whitney Center, a retirement home in Hamden, Connecticut, after the deaths of both their husbands, c. 1990.

182. Judy Chicago, *The Rock Cunt as Portal*, mounted ceramic, 1974, with text: "The Rock Cunt as a Portal, a Passage, or a House of Darkness."

183. Petroglyphs on Galisteo's northern creston. Photo: Sam Ryman, 2022.

184. Harmony Hammond, *Fan Lady*, 1979. Collaged over a proof of the 1978 etching *Oval Braid* with text: "Spinster — A woman who whirls & twirls — to revert — to turn things upside down — spin — weave —communicate."

185. Nicholas Trofimuk, *El Puente de Galisteo*, New Mexico, 2005. The photographer is a longtime Galistean.

186. Caroline Hinkley, *Skellig Michael Cliffs*, 2010. Photographed on an island off the south coast of county Kerry, Ireland, best known for its Gaelic monastery (see steps at lower right), founded between the 6th and 8th centuries.

187. Ethan Ryman selling the neighbors' Sunday papers in Chautauqua, Boulder, Colorado, 1973. A city kid, he didn't get the idea of newspaper delivery and saw an opportunity; we returned the papers.

188. LRL and Charles Simonds in Chautauqua, Boulder, Colorado, 1973.

189. Outside Agitators, anti-Reagan political street theatre at the University of Colorado, Boulder, c.1985. LRL, second on left, wearing a "Fuck You Mr. President" t-shirt.

190. Damage Control, political street theatre, Boulder, 1991. Left to right: LRL, Jennifer Heath, Kristine Smock, Annie Hockmeyer and Caroline Hinkley as Barbara and George Bush, protesting Desert Storm.

191. Melanie Yazzie (Diné), *Dead Sheep's Head*, clay, c. 1993, with Kristine Smock, *Skeleton*, painted clay, 1989; *Topsy Turvy Doll*, turn her upside down and she changes races; I don't remember where she came from; Melanie Yazzie (Diné), *Corn*, painted collage, postcard from Boise Idaho, 2002; *Mixing It Up 1988*: Beverly Buchanan, LRL, Amalia Mesa Bains, and Yong Soon Min, Boulder (Jaune Quick-To-See Smith was the fourth participant that year); Beverly Buchanan, *Shack*, wood, 2011; Melanie Yazzie (Diné) *They Wander Around Us*, oil on canvas, 2011; Bessie Harvey, *Night Mare*, wood and mixed media, n.d. Feeling flush after a lecture in Asheville, N.C., in the 1990s, I bought this wild rider.

192. Juan Sanchez, *Recoge tu Destino, Boricano, en esta luz que se ha tornado petrea. Ni sol, ni lluvia, ni traición, ni nada, podrá borrar lo que se ha escrito en piedra!* lithograph and mixed media, artists proof, 1986; Kathy Vargas, *Niño Fidencio, Curandero,* taken when Vargas was working with Kay Turner on her altars research, between 1986 and 1991; Kathy Vargas, work print from the series *Oracion: Valentine's Day/Day of the Dead*, 1989-1991, and tin calavera hung with Nepalese jewelry, all from Vargas; Yolanda Lopez, *La Mano del Poder*, poster, 1997, inscribed "For Lucy Lippard, a heroine in a historically hysterical time...*con cariño y respecto, tu hermana,* Yolanda"; Kay Miller, *Couple*, ink on paper, 2001.

192A. Lucy R. Lippard, *Mixed Blessings: New Art in a Multicultural America*, New York: The New Press, 1990.

193. *Margaret Isham Cross Lippard: A Good Life*, booklet published by LRL for her memorial at the Kennebec Point house, July 18, 1992.

194. LRL peeling potatoes at land grant protest in Tierra Amarilla, New Mexico, 1988. Photo: Caroline Hinkley. In the background is a poster reading: *Buenas Dias, Chinga el Inglés Official*, from a Colorado campaign against English Only legislation in the 1980s. I have a copy posted on my Galisteo front door, to the amusement of some delivery people.

195. A white mule in Chinle Wash who appeared during our raft trip down the San Juan River, c. 1988.

196. Bumper stickers on LRL cars, 1992 to present.

197. Lucy R. Lippard, *The Lure of the Local: Senses of Place in a Multicentered Society,* New York: The New Press, 1997; *On the Beaten Track: Tourism, Art, and Place*, New York: The New Press, 1999.

198. Peter Woodruff, *Dalrymple/Woodruff House*, watercolor, n.d. The artist's family home at the end of Kennebec Point.

199. Bowl of found artifacts from my land in New Mexico and Maine in a metal plate found near my pumphouse.

200. Peter Woodruff, *Self Portrait*, carved stone, c. 1996.

201. Harmony Hammond, *Rims (Dark Blue/Red)*, monotype printed on grommeted Twinrocker paper by Marina Ancona at 10 Grand Press, 2011.

202. Lucy R. Lippard, *Florence Pierce: In Touch with Light*, Santa Fe: Twin Palms/The Smith Book Fund/ Charlotte Jackson Fine Art, 1998.

203. Richard Shuff, *Galisteo Panoramas*: Cerro Pelon and Harmony's stone wall, c. 1999.

204. Catherine Ferguson, *Galisteo Landscape*, 1992. I acquired this watercolor from a longtime Galistean artist at our annual Studio Tour.

205. 14 Avenida Vieja, LRL's Galisteo house when first built, 1993. Photo: Rudolf Baranik.

206. China emerging from the high grass on our Kennebec Point beach, greeting the sailor home from the sea, 1991.

207. *City of Women*, map in conjunction with Rebecca Solnit and Joshua Jelly-Schapiro, eds., *Nonstop Metropolis: A New York City Atlas*, Oakland: University of California Press, 2016.

208. Patsy Norvell, *Yucca* (Parallel Series), 2007. A real yucca pod that has aged, and a painted image of it in its original state.

209. Nancy Holt, *Xerox Piece*, 2001. "This is a FACSIMILE COPY of a PHOTOGRAPH of a VIDEOTAPED IMAGE of a VIDEOTAPED IMAGE of a PHOTOGRAPH of a PAINTING of a PHOTOGRAPH of a GARDEN."

210. Michele Goodman, *The Halumina Club*, a historical photo of miners transformed with the faces of HArmony, LUcy, MIchele and NAncy, commemorating an epic hike from Cerrillos to Galisteo along the Galisteo Creek, c. 2011.

211. Laura Yeats, *Orb*, wood, 2021, and stone ball from Pueblo Blanco. I felt guilty about letting a friend bring this stone home, but a visiting archaeologist didn't seem to think it was important. It may have been a defensive weapon, dropped on invaders from upper stories of the pueblo.

212. Peggy Diggs, signs for the Galisteo Gals at a Santa Fe Protest, 2017.

213. Ed Epping, *Secreted Contract*, artist's book, Granary Books, 1998. An investigation of "various mnemonic systems and the incorporation of an English-language word type (heteronyms) that, like memory, depend upon contextual constructs."

214. Neery Melkonian, curator, David Frankel, ed., *Sniper's Nest: Art That Has Lived with Lucy R. Lippard*, Annandale-on-Hudson: Bard College, 1996. (The cover is *Gregory with Dollar Bill*, 1985, by artist/activist Rachael Romero, who once made street portraits on the sidewalks of downtown New York City.) The exhibition traveled and then ended up at the Museum of Fine Arts, Santa Fe, where most of the work was donated, including all the pieces not included here in STUFF, and a few that came home. The title was taken from an art and politics column I wrote for *In These Times*.

215. *Sniper's Nest*, inside covers: tchotchkes included in exhibition.

216. Ethan, Kyla, and Sam Ryman, 1996. Ten years later, when baby Sam was in 6th grade at Poly Prep, Brooklyn, he made a booklet: *A 17 Year Old Mind in an 11 Year Old Kid* — a fictional bio: "Sam first started playing the guitar in 1997 when he toured the United States with the Rolling Stones. In 2001 Sam won the Grammy for best guitar solo and had to hide from his Mom who thought he was in bed the whole time. Sam was offered a scholarship at Stanford at the age of seven. He refused because he wanted to stay with his family and friends in New York City. Sam made the 2004 book of world records for youngest billionaire…. and plans on spending the rest of his childhood like a regular kid."

217. Kyla and Sam Ryman meet a Native baby at Acoma Pueblo, 1996.

218. Calvin Ryman with Buster, Kennebec Point, 2010. Kyla adopted Buster online from Ecuador; he loved skedaddling on the beach and boat rides in his own life jacket.

219. Luis Jimenez, *Blackjack*, lithograph, 1997; inscribed in pencil speech balloon: "Hi Lucy," plus LRL photo of the artist and his Appaloosa stallion.

220. Detail of *Avanyu* (horned serpent) petroglyph at Pueblo Blanco, in the Galisteo Basin. Photo: Polly Schaafsma. For a few years I was a Site Steward at Blanco. With Bob Ryman's blessing I sold back to him a gorgeous little painting of his and we bought eighty acres of land adjacent to the pueblo as a donation to the Archaeological Conservancy — very appropriate given Bob's *blanco* paintings.

221. *La Puente*, Jan. 1997, first issue of monthly community newsletter, immediately renamed *El Puente*.

222. *El Puente*, May 2006.

223. May Stevens and Rudolf Baranik, mid 1990s.

224. May Stevens, *Los Temerarios*, paint and ink on paper, c. 2006.

225 Mexican calavera, two frowsy cotton-haired female skeletons rowing a boat. I'd given it to May and reclaimed it after her death. It was the model for *Los Temerarios* and several of Stevens's other paintings and prints.

226. May Stevens, *Tic-Tac-Toe,* collage with burned edges on paper, 1996. This was made after New York newspaper accounts of a little girl who had been burned, abused, and murdered.

227. Rudolf Baranik, *Words*, artist's proof, 1981.

228. Marguerite Kahrl, *El Vergonzoso (The Shameless One),* watercolor, 2007. Kahrl grew up with Ethan on Kennebec Point summers and has lived for years in Northern Italy where she works with refugees and permaculture; Bobbe Besold /Tomie Arai, *Year of the Tiger*, 2022. Each year for decades, friends have received the latest zodiac animal on the Chinese Lunar New Year from Tomie Arai; I now have an impressive collection. More recently I have also been receiving Santa Fean Bobbe Besold's New Year images; Diane Marsh, *Study for the Haunted Silence*, pencil drawing, 1992; Mokha Laget, *Capriccio #40*, acrylic gouache on primed linen, 2020; Patricia Boines Potter, *Map Inset*, mixed media assemblage/welded steel frame, # 88/100, 2015; Paula Castillo, *media res*, mild steel, 2001; Barbara Zucker, *Lucy's Eye*, Dichroic coating on plexiglass, 2006; Timmy Simonds, *Teacher's Bouquet*, bleached and dried parsley and micro-greens soaked in glycerin, plexiglass box, 2022.

229. Rock art workshop at Dugout Ranch in Utah with (front row, left to right) LRL, Polly Schaafsma, and Heidi Rudd, owner of the ranch, 1994. Photo: Bernie Ficek-Swenson.

230. Sabra Moore, *Reverse*, metal, paint on wood, 1993.

231. Sabra Moore, Galisteo Basin petroglyph, pen and ink, 2010, made for LRL's book *Down Country*.

232. On top of the radio: rocks, Lucy purse from Melanie Yazzie, Tuscarora rattle made and given to LRL by Jolene Rickard's uncle, Michael Dubuc (Turtle Clan), during my visit to a maple sugar camp on Tuscarora, c. 1992.

233. Rocks, shells, and sherds on the bathroom windowsill. And there are many more rocks around the house.

234. Katharine Wells, drawing of a petroglyph from the 181-acre Wells Preserve and Mesa Prieta Petroglyph Project near Velarde, New Mexico.

235. Visiting bullsnake on Mountain Sheep skull on my portal, where we also found a rattlesnake last year.

236. Bones and antlers in Maine house. A deer scull that is missing its jawbone, which I gave to Noah Jemison for a sculpture, and a seal scull found on a beach by Timmy Simonds.

237. Antlers (sheds) found in the Galisteo Basin.

238. Diamondback Rattler skin, from Luis Jimenez. I moved it into the workroom because it disturbed Navajo friends.

239. The Rio Galisteo *bosque* in winter, below LRL house. For a few years I was on the Board of Earthworks Institute (1994-2012), led by the dedicated Jan-Willem Jansens (now of Ecotone); for its duration, Earthworks was highly successful in its mission to protect the Galisteo watershed and its wetlands, including erosion protection for my house as a trial project.

240. Willard Clark, *San Miguel de Analco, Santa Fe,* zinc linocut, 1937; gift from Jan Brooks and Lane Coulter, close friends and scholars/dealers in southwestern art and antiques.

241. Lucy R. Lippard, *Down Country: The Tano of the Galisteo Basin 1250–1782*, Santa Fe: Museum of New Mexico Press, 2010.

242. Lucy R. Lippard, *Pueblo Chico: Land and Lives in the Village of Galisteo Since 1814*, Santa Fe: Museum of New Mexico Press, 2020.

243. Tobias Anaya, *Guitar*, date unknown. The self-taught artist from one of Galisteo's old families sold his works near the old cemetery until his death in 1989.

244. Miguel Gandert, *La Malinche*, in Matachines dance at Alcalde, NM, 1998.

245. Marc Forman, LRL and Jim Faris at Pueblo Blanco, early 2000s.

246. Jim Faris and Rez Dog at White Sands, 2000. Rez was in a shelter, banished from San Juan Pueblo for going after poultry.

247. James C. Faris, *Navajo and Photography,* Albuquerque: University of New Mexico Press, 1996; reprinted by University of Utah Press, 2003.

248. My earring screen. I've been an earring freak since I belatedly, in my forties, had my ears pierced in Australia. I used to make earrings from hardware. Thanks to Jim, I'm classier now, with a trove of lovely silver and turquoise from New Mexico's indigenous artists, nothing gold, which seems out of place in NM.

249. Jim Faris, Yazzie, Chino, and his offspring visiting for his 75th birthday, 2011. Back row: Matthew Faris, Gretchen Dierken, Kristin Forman, Michael Faris.

250. Along the Colorado River on 2007 raft trip.

251. Chino and Yazzie hoping for a snack, c. 2010.

252. Walt Stevens, *Woods Edge, First Light*, colored pencil, c. 2010.

253. Crosses by Galistean Jean Anaya Moya, and from Ethiopia; Batea plate from Michoacan, Mexico.

254. Haitian crucifix cut from an oil barrel, from my aunt Betsy Langmuir.

255. Nick Herrera, *San Gregorio*, paint on wood, 2002. The Venezuelan physician known for treating the poor for free was only beatified in 2021.

256. Standing Circle from Ethiopia.

257, 258. Ethiopian Christian Coptic Paintings.

259. Lucy R. Lippard, *Undermining: A Wild Ride Through Land Use, Politics, and Art in the Changing West*, New York: The New Press, 2014.

260. Sharon Stewart, *Walking the Ditch*, from the series *Agua es Vida: A Village Life Portrait*, 2003. In Spring 2022, Jim and I visited *la limpia* (ditch cleaning) in El Cerrito, the site of Stuart's project.

261. Meridel Rubenstein, *Millennial Forest*, "pre-am-bertype," vegetable ink printed digitally on tree bark (Mulberry) paper, 2000/2004; Ray Belcher, *White Church, Silverado Set*, 1982; the movie set is visible from my window; Barbara Byers, *Egg*, 2021; Deborah Luster, from *One Big Self, Prisoners of Louisiana*, project with poet C.D. Wright in three Louisiana prisons, 1998; Michael Berman, western landscape (workprint), 2009; Ray Belcher, *Ruin, Two Windows*, 1981; *Native dancers at San Juan Pueblo (Oh-kay Owingue)*, photographer unknown, probably 1930s.

262. LRL's 80th birthday dinner at Harmony Hammond's, April 14, 2017. Photo: Caroline Hinkley. Left to right: Ethan, Sam and Calvin Ryman, Susana Torre, Peggy Diggs, Jim Faris, LRL, Harmony.

263. Jan Brooks, Mixed Blessings/Down Country cake for LRL's 80th birthday party, at home in Galisteo, April 15, 2017.

264. Ethan and Kyla Adams Ryman at the Grand Canyon, 2017. They parted company later that year.

265. In Carboneras, Spain, 2018: Jan Brooks, Harmony Hammond, Susana Torre, LRL, Betsy Hess.

266. Cordova rooftops from a hotel window, Spain trip, 2018.

267. Eagle whistle bought at Teotihuacan, Mexico, February 2020; Eagle with snake on cactus, Mexican.

268. *No Morira La Flor de la Palabra, E-Z-L-N*, textile, 80th birthday gift from Craig Johnson and Armando Espinosa Prieto (Metamorfosis Documentation Project).

269. Heidi Hatrey, *Language is a Virus for Lucy Lippard*, mixed media, 2022.

270. Pandemic trips with Jim around rural east central New Mexico, 2020–2021. Lucy Ranch, the remains of a defunct settlement.

271. Lucy Cemetery.

272. Curious horses on a nearby ranch.

273, 274  Church and outhouse at Los Valles de San Agustin.

275. The late lamented Chino.

276. Corey McGillicuddy, from the *Social Distancing Series*, the photographic body of the Galisteo artist's Quarantine Diary; Jim and LRL with Bumblefoot and Yazzie, 2021.

277. Tanita, who came to live with LRL from an Albuquerque shelter on Cinquo de Mayo, 2021.

278. Sam Ryman on Kennebec Point, 2021.

279. Calvin Ryman and Kyla's dog Cleo on Kennebec Point, 2021.

280. Alexis Rockman, *American Bison*, La Bajada red clay and acrylic polymer on paper, 2017.

281. LRL desk in its usual state.

282. The Women's Caucus for Art Lifetime Achievement Award, 2007. (Now and then I get a handsome award like this and the three below.)

283. Sackler First Award (a glass triangle designed by Judy Chicago), Elizabeth L. Sackler Center for Feminist Art, Brooklyn Museum, 2012.

284. "The Bob" award from the Center for American Places, 2008.

285. the Edgar L. Hewett Award from the New Mexico Association of Museums, by Highlands University student Johnny Alvarez.

286. *What Next?* I made this flyer in the late 1980s in Boulder for some political event. These days it still packs a wallop.

287. *Goodbye for now...* Photo: Mira Burack.

288.  House and front yard. Photo: LRL.

289. Sunset askew. Photo: LRL.

289

Published by New Village Press
bookorders@newvillagepress.net
www.newvillagepress.org
New Village Press is a public-benefit, nonprofit publisher
Distributed by NYU Press

First Edition: November 2023
Library of Congress Control Number: 2023935525

Book design: Michael Motley
Cover photographs: Lucy R. Lippard

Printed in China